December 27, 19

Dear Bert,
Happy Anniversary

Love,
Jw

The Flag Paintings of Childe Hassam

The Flag Paintings of Childe Hassam

Ilene Susan Fort

LOS ANGELES COUNTY MUSEUM OF ART

In association with

HARRY N. ABRAMS, INC., PUBLISHERS, NEW YORK

LIBRARY OF CONGRESS CATALOGING IN PUBLICATION DATA
Fort, Ilene Susan.
 The flag paintings of Childe Hassam; [text by] Ilene Susan Fort.
 p. cm.
 "Exhibition itinerary: National Gallery of Art, Washington, D.C.,
May 8–July 17, 1988; Los Angeles County Museum of Art, August 21–
October 30, 1988; Amon Carter Museum, Fort Worth, January 7–
March 12, 1989; New-York Historical Society, New York, April 20–
June 25, 1989"—T.p. verso.
 Bibliography: p. 122
 ISBN 0–8109–1169–8
 1. Hassam, Childe, 1859–1935—Criticism and interpretation.
2. Painting, American. 3. Painting, Modern—20th century—United
States. 4. World War, 1914–1918—Art and the war. 5. Flags in art.
I. Hassam, Childe, 1859–1935. II. Los Angeles County Museum of Art.
III. National Gallery of Art (U.S.) IV. Title.
ND237.H345F67 1988
759.13—dc 19 87–27713
 CIP

Copublished in 1988 by
Los Angeles County Museum of Art
5905 Wilshire Boulevard
Los Angeles, California 90036
and
Harry N. Abrams, Inc., New York
A Times Mirror Company

Edited by Edward Weisberger
Printed and bound in Italy by Amilcare Pizzi S.p.A., Milan

Contents

Foreword

Childe Hassam created his flag paintings in response to home-front activities in New York during World War I. The paintings are extremely patriotic statements expressing the country's pride in its modernity and technological power. By 1916 the artist was recognized as one of the foremost impressionists in America, and these paintings are stunning impressionist images as well as pictorial icons symbolic of the power of the Allies to be victorious. Hassam's flag paintings rank among his most successful works, and given the present-day love of American impressionism, they are sure to gain a new generation of admirers.

The flag paintings were shown as a series six times during Hassam's lifetime, and subsequently there was only a much abbreviated series exhibition in 1968. "The Flag Paintings of Childe Hassam" is the most complete showing since the 1922 exhibition at the Corcoran Gallery of Art, Washington, D.C. Some paintings previously shown as part of the series were not available for the present exhibition, which is augmented by several major flag paintings. The works have never been seen as a group west of Pittsburgh, so this exhibition, which travels to four major metropolitan areas, presents Hassam's paintings to the widest public ever.

We would like to express our gratitude to Ilene Susan Fort, associate curator of American Art, Los Angeles County Museum of Art, who organized this exhibition. Her scholarly and thoughtful text provides the first comprehensive study of Hassam's flag paintings. We are also indebted to the many institutional and private lenders without whose cooperation this exhibition would not be possible.

Earl A. Powell III
Director
Los Angeles County Museum of Art

J. Carter Brown
Director
National Gallery of Art

Jan K. Muhlert
Director
Amon Carter Museum

James B. Bell
Director
New-York Historical Society

Preface

Childe Hassam's flag paintings have long been admired and sought after because of their tantalizing impressionist qualities and stirring patriotic imagery. My research concerning these paintings began before the exhibition "The Flag Paintings of Childe Hassam" was even conceived. I had been researching Hassam's *Avenue of the Allies: Brazil, Belgium, 1918*, 1918 (pl. 24), which the Los Angeles County Museum of Art owns, for a catalogue of the museum's American collection. While investigating that painting and George Luks's *Czecho-Slovakian Army Entering Vladivostok, Siberia, in 1918*, 1918 (also in the museum's collection), I discovered that information concerning the historical context in which these New York artists created the two paintings was not readily available. This lack of information appears to have been partly caused by a general lack of interest in art related to politics, for both paintings were personal responses to home-front activities and military campaigns of World War I.

The involvement of American artists in the war effort was documented immediately after armistice in Albert E. Gallatin's *Art and the Great War* (1919). Later historians, however, ignored most of the art created in response to the conflict, preferring to discuss art of the period solely in terms of the emerging modernist movement. Milton Brown was one of the few exceptions, devoting an extended treatment to home-front activities in *American Painting from the Armory Show to the Depression* (1955). Yet even Brown approached the topic as an interlude in the course of American art and minimized its significance. Discussions of war-related art have usually consisted of only passing references in studies on specific artists. In 1968 the Bernard Danenberg Galleries, New York, organized an exhibition of some of Hassam's flag paintings but published only a small catalogue with a short note. Hirschl & Adler Galleries, New York, rectified the lacuna on George Bellows with their exhibition and catalogue, *George Bellows and the War Series of 1918* (1983).

The present volume expands the limited information currently known about Hassam's flag paintings. A description of New York during the war years places the paintings in their historical context. The paintings have mainly been discussed solely in terms of impressionism. Here an extended formal and iconographic analysis of the paintings, based on their relationship to French impressionism, the similarities as well as the differences, is provided.

Ilene Susan Fort
Associate curator, American Art
Los Angeles County Museum of Art

By the time World War I began, Childe Hassam was one of the foremost artists in the United States. His reputation as the leading American impressionist had been established with the picturesque city images, sparkling park and garden scenes, and sun-filled interiors he had created in the United States and abroad over the course of thirty years.[1] During the war he completed a group of flag paintings that became his most significant late works. The initial inspiration for these paintings was a patriotic celebration the artist witnessed in wartime New York: "I painted the flag series after we went into the war. There was that Preparedness Day, and I looked up the avenue and saw these wonderful flags waving, and I painted the series of flag pictures after that."[2]

The Preparedness Day that Hassam referred to occurred on May 13, 1916. It consisted of an enormous parade and decorations along Fifth Avenue, which had a distinguished history as an important parade route dating back to about 1860. The parade was the first large-scale public demonstration in support of the creation of a large, well-trained army and represented the beginning of United States involvement in the European conflict, even though the country did not officially enter the war until the following April.

Historical accounts of America's participation in World War I usually focus on the politics of diplomacy and the military campaigns. However, the war could not have been waged without the support of the civilians at home who financed the war, provided moral support for soldiers in combat, and manufactured the weaponry for their battles. The home front, as well as the battle front, was a potent force in the Allied victory. Americans reacted enthusiastically to the Allied cause by extolling ideals of patriotism and liberty. It became the duty of all citizens to participate in a heroic manner, if not in battle, then in a war-related activity at home.

The war was a powerful factor in the lives of Americans, among whom artists were no exception. They made a substantial contribution to the home front through the activities of numerous art organizations, donating their time and art to various causes. Furthermore the war became part of the iconography of their art. Because of its late entry into the war and the fact that battles were not fought on American soil, the United States sent few artists to document activity at the battle front. Instead of recording the actual fighting, many American artists, particularly those based in New York, recorded home-front activities and celebrations. The artistic response was basically innocent, inspired by the public's belief that this was "the war to end all wars" and consequently a good and righteous cause.

Americans throughout the nation organized rallies and parades and decorated their cities with flags and patriotic banners, and these activities were the most visible evidence of the home-front effort. New York, the financial and cultural capital of the country, organized the largest celebrations and displayed the most elaborate decorations. Fifth Avenue became the most splendid parade route in the nation. For the Preparedness Parade grandstands were set up at Madison Square (Twenty-third to Twenty-sixth streets) and at frequent intervals

along Fifth Avenue up to Fifty-eighth Street. The parade lasted almost thirteen hours and numbered more than 137,000 marchers—laborers, businessmen, doctors, teachers, mothers—what President Woodrow Wilson called "citizen soldiery."[3] Among the artists who marched were Edwin H. Blashfield, Charles Dana Gibson, Frederick MacMonnies, and Edward Simmons.

It is not known whether Hassam actually walked in the parade or merely watched it from the sidelines. He might have joined the march with his good friend artist J. Alden Weir, who was anxious to demonstrate his support of France and participated despite ill health.[4] Having studied and lived in Paris, as had Weir, Hassam shared his friend's fondness for the French. Pro-French allegiance was typical of the majority of American artists, who defended a culture they loved dearly that symbolized for them the ideal artistic existence.[5] Moreover, Hassam's pride in his English ancestry allied him with the British. During the war his strong partisanship led him to make several public statements revealing a virulent dislike of Germany and anything German. In a letter to the *New York Times* Hassam condemned that country for always lying, and in another published letter he asserted that the Germans used "the fine arts as a cloak—music, literature and painting are always second to war munitions making."[6]

Hassam did not have to go far to see the Preparedness Parade and the elaborate display of flags and bunting that decorated Fifth Avenue. During the war years his studio was at 130 West Fifty-seventh Street, near Sixth Avenue and just two blocks from the end of the parade route.[7] It was a short walk to the reviewing stands and only a few blocks to Fifty-fifth Street, where an especially elaborate arrangement of American flags hung from the windows of one building. The excitement of the parade and its cause would have been infectious, and Hassam was stimulated to capture this patriotic enthusiasm in *Just off the Avenue, Fifty-third Street, May 1916*, 1916 (pl. 1). However, it is surprising that he did not paint the decorations along Fifth Avenue or the parade itself but selected one of the side streets where only a few flags were hanging. Hassam had been attracted before to the flurry of banners in wartime patriotic displays, as evidenced in the etching *Washington's Birthday*, 1916 (fig. 1), done three months earlier. Although he revealed a preference for more elaborate decorations in subsequent flag paintings, he would continue to avoid portraying actual parades.

Hassam and other American artists had become involved in the international conflict almost immediately after it began. On June 28, 1914, Archduke Francis Ferdinand, heir to the Hapsburg throne, was shot and killed by a Serbian nationalist, and by August political alliances had led to the outbreak of World War I. While the United States remained officially neutral, watching events unfurl across the Atlantic, its citizenry realized the need to assist Great Britain and France. On September 25, 1914, New York painters and sculptors formed the American Artists' Committee of One Hundred.[8] The committee organized an exhibition and sale of paintings and sculpture, with the proceeds going to a relief fund for the families of French soldier-artists. The exhibition

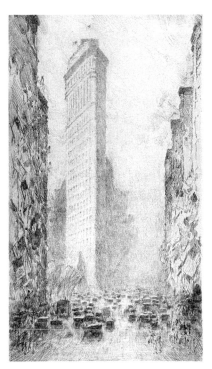

Fig. 1
Childe Hassam
Washington's Birthday, 1916
Etching
13½ x 8³⁄₁₆ in. (34.3 x 20.8 cm.)
Amon Carter Museum, Fort Worth

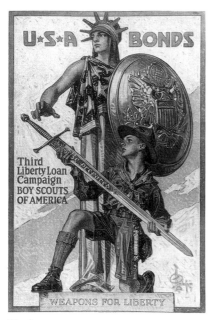

Fig. 2
Joseph C. Leyendecker (United States,
1877–1924)
WEAPONS FOR LIBERTY, 1918
Poster
30 x 20 in. (76.2 x 50.8 cm.)
Henry E. Huntington Library and Art
Gallery, San Marino, California

was held during the first two weeks of February 1915 at the galleries of M.
Knoedler and Company. The wives of a number of artists and architects, Mrs.
Childe Hassam among them, served as patronesses of the exhibition. Hassam
himself served on the committee and contributed a landscape, *The Bay Trees,
Appledore, Isles of Shoals*, n.d. (location unknown); for sale at fifteen hundred dol-
lars, it was one of the higher-priced works in the exhibition.[9] The committee
continued raising money, and by May 1917, shortly after America entered the
war, it numbered 170 members in thirty cities throughout the country. That
May the committee held another large-scale sale of works of art. Hassam, a
member of the special subcommittee that arranged this sale, again contrib-
uted a landscape, *The North Gorge, Appledore*, 1912 (Columbus Museum of
Art).[10]

Relief activities intensified after the United States entered the conflict.
Special exhibitions, organized by associations, commercial galleries, and
museums, promoted the war effort by raising relief funds and inspiring patri-
otism. Although not always showing war-related art, the exhibitions focused
increasingly on martial themes as the fighting progressed. The National Acad-
emy of Design set up its own relief fund and donated money to the American
Artists War Emergency Fund, which had been established by the National Arts
Club. So many art organizations set up relief funds that the Art War Relief was
formed in December 1917 to coordinate "the various war activities of art orga-
nizations, individual artists and those interested in art."[11] Its most important
work was humanitarian, for it acted as a Red Cross auxiliary. The Art War
Relief also had a Painters Committee, which organized the painting of
hundreds of landscape targets for artillery practice and assisted the federal gov-
ernment's publicity department in making posters. The Art War Relief raised
considerable money from the sale of Alfred Noyes's book *The Avenue of the Allies
and Victory* (1918), in which Hassam's *Allies Day, May 1917*, 1917 (pl. 8), served
as frontispiece, and from sales of a color reproduction after the painting.[12]

During the first years of the war many Americans, including President
Wilson, had been isolationists, asserting that the war was a European problem.
Because the conflict was far away, it did not at first substantially influence the
imagery of American artists. Nor did the pacifist movement in the United
States and abroad produce much antiwar imagery.[13] This art usually took the
form of political cartoons, which appeared in socialist-oriented journals espous-
ing the belief that the war was promoted by industrial capitalists and would
prevent the progress of social reforms. Many of the most important
antiwar cartoons were published in *The Masses*, a New York-based leftist journal
edited by Max Eastman with the assistance of John Reed. Robert Minor and
Henry Glintenkamp contributed drawings opposed to conscription, while Art
Young, Boardman Robinson, and other artists attacked wartime profiteering
and the clergy's prowar stance. *The Masses* ceased publication in December 1917,
silenced largely by the restrictions imposed by the Espionage Act of 1917.[14]

By the time the United States declared war on April 6, 1917, most Amer-

icans believed the Allies were fighting a just cause and recognized the necessity of joining in their battle. Citizens quickly rallied in support of the war. During the year and a half that the United States was a combatant, New York and other cities were actively involved in the home-front effort. On April 19, 1917, citizens marched on Fifth Avenue in the Wake Up America Parade, and six weeks later the First Liberty Loan Drive began, encouraging Americans to lend money to the federal government by buying bonds that would cover the cost of the war. During each of the five Liberty Loan Drives, New York City residences and businesses were decorated with flags, signs, and emblems. The Fifth Avenue Association, established by a group of merchants in 1907 to safeguard the quality of the street's appearance, was in charge of organizing most of the decorative displays along the avenue.

Two days before the Wake Up America Parade, the National Committee on Public Information established a Division of Pictorial Publicity as a means of organizing artistic activities in support of the war effort.[15] Headquartered in New York, the division was organized after a group of illustrators and painters, led by illustrator Charles Dana Gibson, went to Washington, D.C., to offer their support.[16] Gibson was chosen chairman of the division, and associate chairmen included architect Cass Gilbert, sculptor Herbert Adams, printmaker Joseph Pennell, and painters Edwin H. Blashfield, Arthur F. Mathews, and Edmund Tarbell.[17] Several of these chairmen served as the heads of geographical subdivisions outside New York.[18] According to Albert E. Gallatin, who became historian of the art effort, the division supplied "the various departments, bureaus and commissions of the government with every form of pictorial publicity that they desired."[19] Although usually referred to as "pictorial publicity," much of the art created was propaganda aimed at encouraging patriotism and support of the Allied cause. In the decades prior to World War I European governments learned the effectiveness of using art for political ends, and during the first months of the war they issued countless posters, pictures, and pamphlets to inspire patriotism.[20]

During the year and a half of its existence the Division of Pictorial Publicity was instrumental in the creation of 700 posters, 287 cartoons, and 432 designs for newspaper advertisements. These items were given not only to federal and local governments but also to organizations involved in the war effort, such as the Red Cross, the Shipping Board, the Salvation Army, and the Young Men's Christian Association.[21] Contributing their services, artists designed posters for specific events as well as for the five Liberty Loan Drives. Among these artists were W. T. Benda, Blashfield, Howard Chandler Christy, James Montgomery Flagg, Edward Penfield, Pennell, and Henry Reuterdahl.[22] The posters varied substantially in style, iconography, and effect. Among the most widely used images were Uncle Sam, Miss Liberty or a variation such as the Statue of Liberty, and the Stars and Stripes. The American flag was an extremely potent symbol of unity and liberty and often appeared in conjunction with other stock subjects, as in Joseph C. Leyendecker's *Weapons for Liberty*,

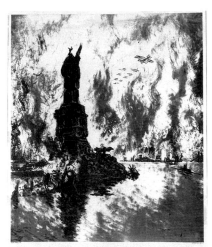

THAT LIBERTY SHALL NOT PERISH FROM THE EARTH BUY LIBERTY BONDS
FOURTH LIBERTY LOAN

Fig. 3
Joseph Pennell (United States, 1860–1926)
THAT LIBERTY SHALL NOT PERISH, 1918
Poster
23½ x 20¼ in. (59.7 x 51.4 cm.)
Toby C. Moss Gallery, Los Angeles

Fig. 4
Childe Hassam
CAMOUFLAGE, 1918
Lithograph
7 x 11 in. (17.7 x 27.9 cm.)
Corcoran Gallery of Art,
Washington, D.C.
Gift of Mrs. Childe Hassam, 1940

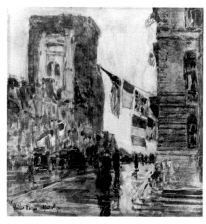

Fig. 5
Childe Hassam
FIFTH AVENUE, APRIL MORNING, 1917
Watercolor on paper
11½ x 10¾ in. (29.2 x 27.3 cm.)
Sheldon Memorial Art Gallery, University
of Nebraska-Lincoln
F. M. Hall Collection

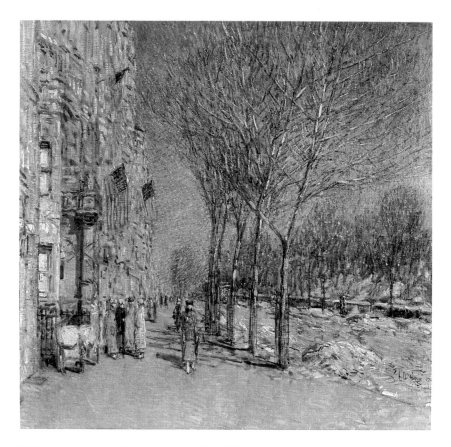

1918, in which the flag serves as Miss Liberty's robe (fig. 2). One of the most stirring and popular posters was Pennell's *That Liberty Shall Not Perish*, 1918, an image of New York under attack in which the Statue of Liberty's head lies in rubble at her feet (fig. 3).

In May 1918 the Committee on Arts and Decoration was established as a subdivision of the Mayor's Committee on National Defense for the City of New York.[23] Its stated purpose was quite general: to develop the field of art in connection with the war.[24] Gallatin was appointed chairman, and the executive board included architect Thomas Hastings, sculptor Paul Manship, painter Guy Pène du Bois, and educator Nicholas Murray Butler. The committee included artists of different aesthetic persuasions, a few who served in the Division of Pictorial Publicity as well as others who did not, such as Bryson Burroughs, Jules Guerin, Ernest Lawson, Augustus Vincent Tack, and Hassam.[25]

The Committee on Arts and Decoration became a general clearinghouse for information. Gallatin received hundreds of letters from artists all over the country who wanted to help the war effort but did not know how to apply their special talents.[26] In addition to answering these letters, in the summer of 1918 the committee issued a leaflet containing suggestions and information on art-

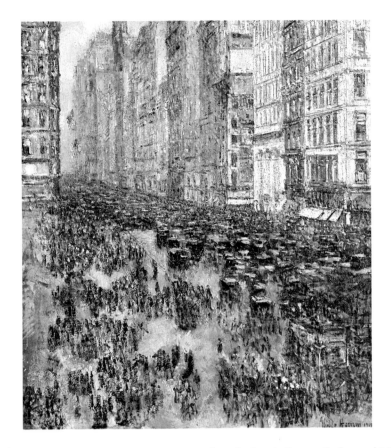

ists' war work. [27] In this respect the committee had an influence far beyond New York and was commended by Henry MacDonald, director general of the Mayor's Committee on National Defense:

> I confess to having had but a faint idea previously as to the definite advice which you [Gallatin] were in a position to give artists, architects, sculptors, and those practicing the allied arts who desire to apply their knowledge to war work, but a perusal of the material which you have generously prepared and donated for the use of the Mayor's Committee has shown to me how widely useful is the scope of war activities....The suggestions which you make regarding posters, cartoons, designation targets, industrial housing, military and naval camouflage, decorations, etc.,...cannot fail to be of great benefit. [28]

When, for example, Samuel Halpert of New York and John Grabach of New Jersey, two artists who painted landscapes and cityscapes, wrote to Gallatin, he suggested they try making designated targets. [29] These were large landscapes depicting French rural scenery that were used as range finders in the

13

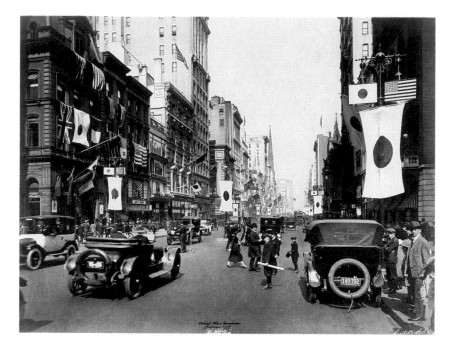

training of artillery skills. The Art War Relief monitored much of this type of work, and in New York many members of the Salmagundi Club, the National Academy of Design, and Ver Meer Studio were responsible for creating several hundred targets. Among the more active painters of range finders were the brothers Hugh Bolton Jones and Francis Coates Jones, as well as Colin Campell Cooper, Chauncey Ryder, and Henry B. Snell.[30] Other painters turned to camouflage, whose theoretical underpinnings were heavily indebted to the work of American artist Abbott Handerson Thayer.[31] Louis Bouché and other artists who did camouflage work were commissioned as captains in the army's Fortieth Corps of Engineers.[32]

More visible to the general public was the Committee on Arts and Decoration's supervision of the floats and decorations used for various parades and celebrations. New York had already experienced much patriotic pageantry, but the city's most elaborate displays were yet to come. The committee began by acting as artistic censor for the historic floats, banners, and costumes used in the huge Independence Day Pageant-Parade of 1918. The Liberty Loan Committee had its own subcommittee on art, and the two organizations worked in close cooperation.[33]

Hassam was willing to assist in the kinds of utilitarian war work suggested by the Committee on Arts and Decoration, but his services were apparently not required. In 1927 he was interviewed about his war activities:

{Dewitt McClellan} Lockman: Did you do any of the range finders?

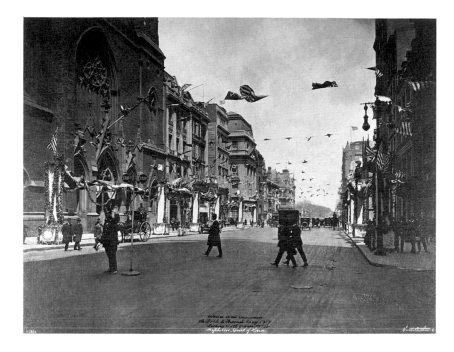

Fig. 10
Wurts Brothers, New York
Photograph of Fifth Avenue looking
north from Fifty-fifth Street during visit of
British and French war commissioners,
May 1917
United States History, Local History and
Genealogy Division, The New York Public
Library, Astor, Lenox and Tilden
Foundations

Hassam: I was interested in doing anything that I could to help them. I went up to see [Hugh Bolton?] Jones and his work and what other men had done, but they said "we do not need you to do this!"

Lockman: Did you do any other war work?

Hassam: No, I did no other war work....Gallatin thought it was a pity that the Government did not send me abroad to make a record of the war, as the French and English did with their artists. He thought I was the man for it, and to record in the various mediums the work that was being done by the American forces. But the Government paid no attention to this.[34]

In the lithographs *The North River*, 1917, *The French Cruiser*, 1918, and *Camouflage*, 1918 (fig. 4), Hassam delineated the naval maneuvers taking place along the city's rivers.[35] On April 17, 1918, while sketching *Camouflage* in Riverside Park along the Hudson River, he was arrested for violating a federal regulation prohibiting such activity.[36] He was not bothered by the arrest but actually glad the police were protecting native shores from alien infiltration. Military operations did not substantially alter New York's appearance, and Hassam, when recording how the city was transformed during the war, concentrated on such home-front activities as the Liberty Loan Drives.

The decorated streets offered an attractive spectacle, which Hassam captured in prints and watercolors (for example, fig. 5) as well as oils. The exact

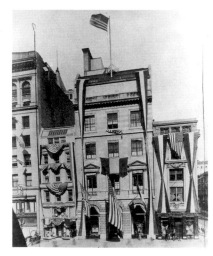

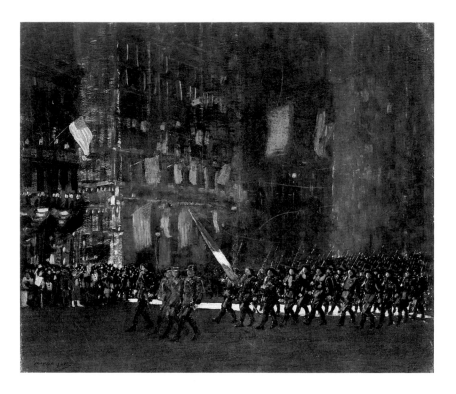

number of flag paintings in oil that he created during the years 1916 to 1919 is
not known. It was probably almost thirty. The works usually referred to as flag
paintings are the images of New York bedecked with flags that Hassam created
during and shortly after the war. The inclusion of banners is not the only
requirement for considering a New York scene a flag painting. The image must
be of Fifth Avenue or a nearby street where the flag decorations made a signif-
icant statement about American support of and participation in World War I.
New York Landscape, 1918 (fig. 6), a park scene more typical of Hassam's earlier
urban images, is not in accord with the established flag imagery, nor is *Fifth
Avenue*, 1919 (fig. 7), in which an American flag hanging from a distant build-
ing appears so tiny as to be an insignificant part of the total scene. Most of the
flag paintings were exhibited after the war as a series, and there has been con-
fusion over whether all the flag paintings were part of this series or, if not all,
which ones. In this volume the term "flag series" is used only when referring to
the flag paintings Hassam actually exhibited as a formal group.

Flags had long been used to decorate American cities on national holidays
and other special events. About 1909, in a drawing of New York similar to Has-
sam's later images, Pennell depicted large United States flags suspended over
lower Broadway during an election (fig. 8). During the first years of the war,
before America formally entered the conflict, flag displays rarely included the
national banners of countries other than the United States (pls. 1–5). The times

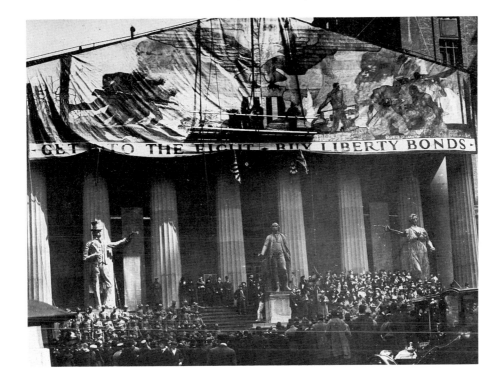

so stirred patriotic sentiment that "The Star-Spangled Banner" achieved a popularity it had not experienced since Francis Scott Key composed the verses in 1814. Private citizens and public officials began to consider it the national anthem, even though this formal designation did not occur until 1931.

Other national flags began to appear with increasing frequency as soon as the United States formally declared war. Hassam painted *Allied Flags, April 1917* (pl. 7) during the month the country officially entered the conflict and perhaps on the actual day war was declared. The painting symbolizes America joining forces with the Allies: Old Glory and eleven other flags are hung from a balcony on the Fifth Avenue side of the Union League Club. Hassam included himself as one of the pedestrians, thereby suggesting that he, like all patriotic Americans, was now involved in the war effort.

During the following months Hassam did a number of flag paintings, no doubt inspired by the heightened war sentiment and the increased number of war-related ceremonies. The war commissioners, top-ranking officials in charge of directing the war campaigns of each Allied country, visited the United States to confer with political and military leaders. As part of their official tours the commissioners visited New York: on May 9, 1917, the British commissioner arrived; on May 11 the French, on June 21 the Italian, on July 6 the Russian, and on September 27 the Japanese (fig. 9). For each visit official receptions and parades were held, and the flag of the particular country being honored flew

Fig. 13 (opposite right)
George Luks (United States, 1867–1933)
BLUE DEVILS ON FIFTH AVENUE, 1917
Oil on canvas
38⅞ x 44½ in. (98.7 x 113 cm.)
The Phillips Collection, Washington, D.C.

Fig. 14 (above)
Paul Thompson
Photograph of Henry Reuterdahl and N.C. Wyeth completing painting on Sub-Treasury Building as part of Third Liberty Loan Drive, April 1918
The National Archives, Washington, D.C.

17

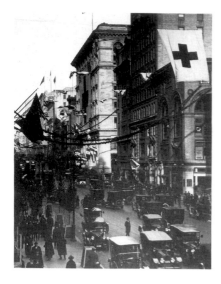

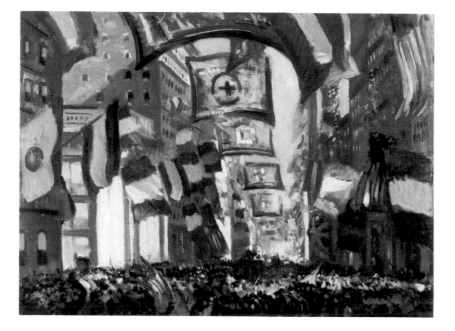

throughout the city. The Mayor's Committee on Decoration, headed by Cass Gilbert, allocated decorations to various locales, some of which had been traditionally used for receptions of political dignitaries and celebrations of historical importance: Battery Park, City Hall, Washington Square Arch, Fifth Avenue, Broadway, and Riverside Drive.[37] Hassam may have created *Up the Avenue from Thirty-fourth Street, May 1917, Avenue of the Allies,* and *Early Morning on the Avenue in May 1917,* all from 1917 (pls. 9–11), during the visits of the French and British war commissioners (fig. 10).

The displays created during and after the visits of the war commissioners usually focused on Great Britain and France, the countries that historically had maintained the closest relations with the United States. The Mayor's Committee on Decorations asked citizens to hang the flags of these Allies in conjunction with the Stars and Stripes (fig. 11). Such a grouping appears in a number of paintings Hassam made in 1917 (pls. 8 and 12) and is one of the major differences between his 1916 and 1917 depictions of a flag-decorated Waldorf-Astoria Hotel (pls. 3 and 10). Alice Heath, whose images were reproduced as color lithographs in Henry Collins Brown's *New York of To-Day* (1917), moved all around the city to paint many of the 1917 flag decorations, enjoying the differences in presentation afforded by crowded narrow streets and grand avenues. Hassam, however, focused entirely on mid-Manhattan near or on Fifth Avenue. Only in 1918 did he once make an excursion to lower Manhattan for the lithograph *Lafayette Street* (fig. 12).

As the war continued, New York's celebrations and street displays increased in frequency and elaborateness. George Luks painted the French

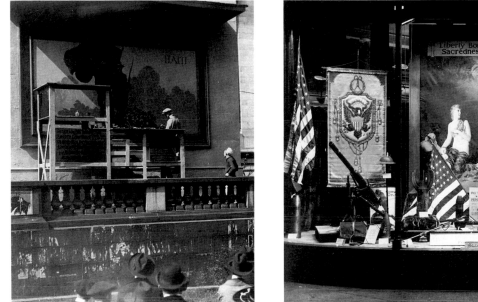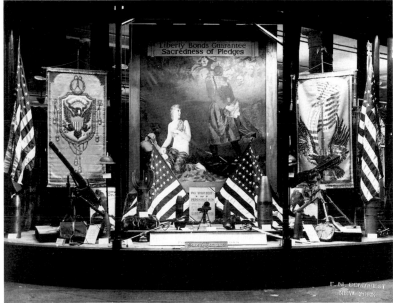

poilus—more commonly known as the Blue Devils because of their bravery and the color of their uniform—when they visited New York during one of the Liberty Loan Drives (fig. 13).[38] He depicted the platoon as it strutted past Delmonico's Restaurant at Forty-fifth Street and Fifth Avenue. Hassam's *The Union Jack, April Morning, 1918*, 1918 (pl. 15), may commemorate the first anniversary of America's entry into the war.[39] It is not known whether he painted the image exactly on April 6 or at some other time during the Third Liberty Loan Drive, which opened on the anniversary and ended on May 4. Widespread American support of the Allied cause was symbolized by placing Old Glory directly behind the Union Jack. For the Third Liberty Loan Drive, Reuterdahl and N. C. Wyeth created a huge allegorical war painting that covered the entire pediment of the Sub-Treasury Building on Wall Street, where rallies were held daily (fig. 14).[40]

On May 18, 1918, the American Red Cross held a parade on Fifth Avenue and sponsored a special drive to raise funds during the week of May 20 to 27 (fig. 15). At that time Hassam painted two more flag scenes. The organization's simple banner with a red cross on a white field grandly commands the avenue in his *Red Cross Drive, May 1918*, 1918 (pl. 17), as well as in Gifford Beal's less monumental but more dynamic *Armistice Day*, c. 1918 (fig. 16).[41] The Red Cross banner takes a secondary role in Hassam's *Italian Day, May 1918*, 1918 (pl. 18). Italy-America Day, held May 24 during Red Cross Week, commemorated the third anniversary of Italy's entry into the war against Germany, its former ally. Because of the substantial Italian population in New York the observance was especially enthusiastic. Hassam underscored the rapport

Fig. 17
Western Newspaper Union
Photograph of Franklin Booth painting Haiti scene before the New York Public Library as part of Fourth Liberty Loan Drive, October 7, 1918
The National Archives, Washington, D.C.

Fig. 18
F. M. Demarest
Photograph of patriotic display in window of Saks and Company during Fourth Liberty Loan Drive, 1918
The National Archives, Washington, D.C.

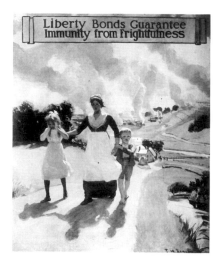

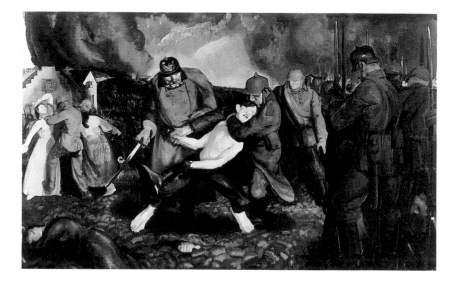

Fig. 19
Frank Benson (United States, 1862–1951)
*LIBERTY BONDS GUARANTEE IMMUNITY
FROM FRIGHTFULNESS*, 1918
Poster for Fourth Liberty Loan Drive

Fig. 20
George Bellows (United States,
1882–1925)
THE GERMANS ARRIVE, 1918
Oil on canvas
49½ x 79¼ in. (125.7 x 201.3 cm.)
Estate of Emma S. Bellows

between Italy and the United States by placing the national banners of the two countries close together and on a similar scale. The large international display at the Independence Day celebrations of 1918 inspired Hassam, Weir, Pennell, and other artists to promote an exhibition of arts and crafts from countries that had lost their freedom after German invasion, but the war ended before the show could be held.

With each new Liberty Loan Drive the street decorations became more elaborate, culminating in the Fourth Liberty Loan Drive, held during the autumn of 1918. Hassam responded with his most concentrated effort, creating five paintings in less than three weeks (pls. 20–24). So lavish were the planned decorations and special displays that the Fifth Avenue Association called for assistance from the Liberty Loan Committee. The committee's publicity department established an Advisory Art Commission, with H. Van Buren Magonigle as chairman.[42] The commission decided to concentrate its efforts on Fifth Avenue and placed James Monroe Hewlett in charge. The Fourth Liberty Loan festivities were truly distinctive, for they included not only parades, rallies, and flags decorating the avenue but also special window displays, an Altar of Liberty, a Liberty Studio, a Liberty Theater, and nighttime community singing. Each day of the drive was devoted to a different Allied nation—from September 28, Belgium Day, to October 19, United States Day.[43] The city's best-known artists, architects, and advertising people were consulted for the decorations, and more artists participated in activities than in any previous drive.

The Liberty Studio was an outdoor display set up on the steps outside the entrance to the New York Public Library at Fifth Avenue (Fortieth to Forty-second streets). Each day of the drive a crowd of pedestrians watched a different artist paint, on a large-scale framed canvas, a picture devoted to the Allied country of the day (fig. 17). The nation's spirit was conveyed in symbolic or

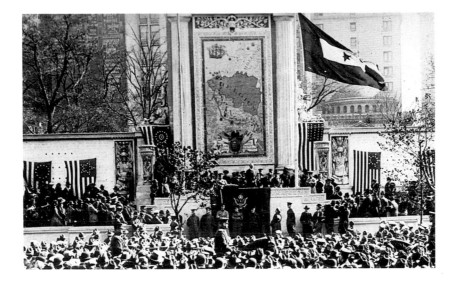

Fig. 21
Underwood and Underwood
Photograph of Thomas Hastings's Altar of
Liberty during United States Day, Fourth
Liberty Loan Drive, October 19, 1918
The National Archives, Washington, D.C.

representational terms, depending on the temperament of the artist. Among those who painted at the Liberty Studio were several notable illustrators and realist painters: Christy, Arthur Crisp, Gibson, William Glackens, Jonas Lie, and Louis Mora.[44] A critic ranked Glackens's Russian image the best, and Gibson's *Miss Liberty* was highly praised for ending the drive on an especially patriotic note.[45] No doubt it was exciting for the public to watch artists at work, especially when live models were used. The artists were praised for working under such adverse conditions and having "taught New York a lesson. They have shown that they are not apart from the life of the community and the nation. They brought into the great drive, into the great effort to raise money, an intellectual and imaginative quality of the greatest importance."[46] The paintings were to have been reproduced as color postcards and used for propaganda abroad, but the armistice put an end to the idea.[47]

The day after each painting was created, it was moved to a shopwindow along Fifth Avenue and became part of what was called the largest art exhibition in support of the war effort. About one hundred paintings along with prints, posters, flags, and other patriotic items were displayed in Fifth Avenue store windows from Twenty-third to Fifty-ninth streets (fig. 18). L. C. Boochever of the Liberty Loan Committee was in charge of the Window Display Bureau, but it was actually Augustus Vincent Tack who thought of the idea and spurred his comrades on.[48] So spirited were the artists that none who were asked to participate declined. The contributors included Beal, Gutzon Borglum, George C. Browne, Arthur Dove, Hugh Ferris, A. C. Goodwin, Hassam, Hugh Bolton Jones, Leon Kroll, Lie, Will Low, Gari Melchers, Willy Pogany, Gardner Symons, Tack, and Douglas Volk.[49] Often the primary display in the shopwindows, the paintings revealed artistic responses to the war varying from symbols of patriotism and valor to industrial factory scenes and unflinchingly realistic

**Proposed Decoration of Fifth Ave
Fourth Liberty Loan Drive**

Diagram of Sequence of National Flags

Corrected Sept 10, 1918

NAME OF STREET

Flag	Street
US & Liberty Loan	58
US & Liberty Loan	57
Belgium	56
Brazil	55
British Empire	54
China	53
US & Liberty Loan	52
All Ass'd Nations	51
Cathedral	50
US & Liberty Loan	49
Cuba	48
Czecho Slovakia	47
France	46
Greece	45
Guatemala	44
Haiti	43
US & Liberty Loan	42
All Ass'd Nations — Library	41
	40
US & Liberty Loan	39
Honduras	38
Italy	37
Japan	36
Liberia	35
Montenegro	34
Nicaragua	33
Panama	32
Portugal	31
Russia	30
Serbia	29
Siam	28
US & Liberty Loan	27
US & Liberty Loan	26
All Ass'd Nations	Altar of Liberty

Fig. 22
Proposed decoration of Fifth Avenue for
Fourth Liberty Loan Drive based on
diagram in *Avenue* (Fifth Avenue
Association) 2 (October 1918): 3

accounts of the enemy's destruction and cruelty. In the window of the Knoedler galleries Blashfield's *Carry On*, 1918 (formerly Metropolitan Museum of Art, New York), an image of Miss Liberty, attracted large crowds and was a classic example of how a conservative artist used allegorical figures for World War I themes. Kurzman's, the millinery shop, had a window display of Pennell's etchings of such wartime industries as shipyards and munitions plants.[50] Frank Benson's scene of a mother and her two children fleeing their burning village was placed in the window of the art gallery of Duveen Brothers (fig. 19). Hassam showed several flag paintings in one of the store windows, but it is not known which canvases were exhibited or where.[51]

Realizing the propaganda value, critics preferred the few paintings that showed the true destruction and misery caused by the war: "The message should be delivered in strong, brutal language such as the horrible painting by S. J. Wolff where the soldier displays his hideous stumps of arms—or Bellows' scene [*The Germans Arrive*, 1918 (fig. 20)] of a Belgian who lies swooning in the arms of his torturers."[52] Indeed the crowds stood longest in front of Bellows's horrific image in the window of Scott and Fowles. The leitmotiv running through all the paintings was the American hatred of what Germany had done to Europe and the determination that such a war not be allowed to recur.[53]

Thomas Hastings designed an Altar of Liberty, which was placed along the Fifth Avenue side of Madison Square between Twenty-fourth and Twenty-fifth streets.[54] It was forty feet high, with panels on each side of a large map of Europe (fig. 21). Dedicated to the ideals of democracy and liberty, the altar was the central feature of the daily activities of the Fourth Liberty Loan Drive. The flag of the Allied country of the day was officially raised on a pole near the altar, which served as the official reviewing stand for parades as well as the reception stand for visiting foreign dignitaries. The altar was later incorporated into the decorations used for the victory celebrations welcoming troops home.[55]

The Fourth Liberty Loan celebrations focused on familiarizing the public with the flags of the Allies and interpreting the spirit of sacrifice these nations had shown in the war.[56] As the Fifth Avenue Association explained, "It is felt that the story of Fifth Avenue's tribute to the Allied flags will...be a source of new hope and inspiration among all the people fighting against autocracy and brute force."[57] The flag decorations entailed the most complex organization. Benjamin Strong, chairman of the Liberty Loan Committee for the New York District, explained the motive for this elaborate display:

> We have felt for some time that the national flags of the nations associated in the winning of the war had been neglected. In fact, I have received unofficial protests from representatives of some smaller nations because their national flags...had not been displayed prominently in connection with Liberty Loan activities.
>
> The plan, as at present worked out, seems to me to insure one of the most remarkable displays in the history of this country. It will be a display

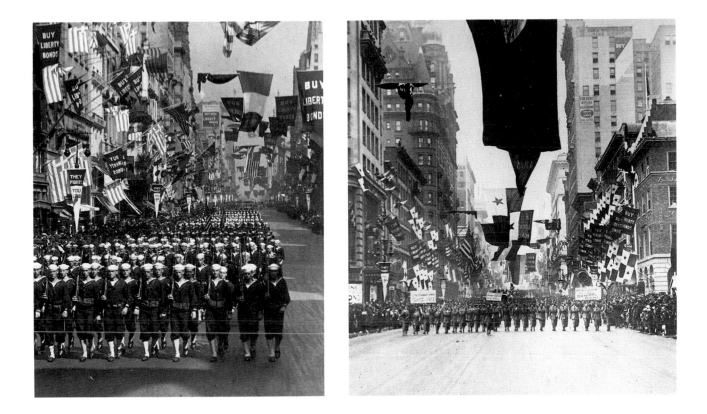

typical of the deep sentiment and enthusiasm on the part of all of the people of this great city, no matter what their origin, for the winning of the war.

We have always regarded Fifth Avenue as a most important element in our campaign work....It is well understood that events taking place on Fifth Avenue are reported throughout the United States and throughout the world through the press and through pictures.[58]

Flags, pennants, and bunting were hung along and across Fifth Avenue for thirty-four blocks from Madison Square at Twenty-fourth Street up to Fifty-eighth Street.[59] Each block was devoted to a different Allied nation, all alphabetically arranged from Belgium to Siam, with special streets allocated to combined displays of Liberty Loan and United States flags (fig. 22). Heretofore the flags of other Allied nations flew along the avenue but not in such number or variety. In the Fourth Liberty Loan celebrations small countries such as Siam, Guatemala, and Liberia were represented on an equal basis for the first time. In some cases the national banners had never previously been displayed in New York and had to be specially made.[60] Flags of specific countries were hung from the second- and fourth-floor windows of every building, while Liberty Loan

Fig. 23
Western Newspaper Union
Photograph of sailors marching on Fifth
Avenue during Fourth Liberty Loan
Drive, 1918
The National Archives, Washington, D.C.

Fig. 24
Underwood and Underwood
Photograph of Liberty Day Parade during
Fourth Liberty Loan Drive, 1918
The National Archives, Washington, D.C.

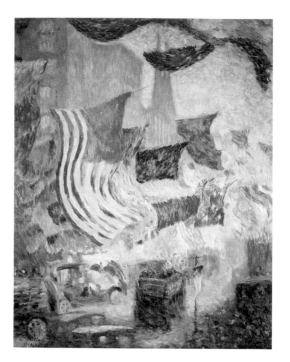

Fig. 25
Theodore Earl Butler (United States,
1861–1936)
FLAG DAY, 1918
Oil on canvas
39½ x 31½ in. (100.3 x 80 cm.)
Private collection

flags hung from third-floor windows. The block was further marked at each end
with a large banner strung across the avenue bearing the name of the Allied
country, and midway in each block a large flag of the country was suspended
across the street (figs. 23–24). United States flags decorated the blocks desig-
nated as special Liberty Loan areas (Twenty-sixth to Twenty-eighth and Fifty-
sixth to Fifty-eighth streets). The flags and standards of all nations hung from
poles in front of Madison Square, the New York Public Library, and Saint
Patrick's Cathedral (Fiftieth to Fifty-first streets).[61] Special red Liberty Loan
banners were displayed throughout and served as backgrounds for the brightly
colored national flags. Street lamps had special amber-colored shades added to
provide a soft glow in the evening.[62] Although other American cities were dec-
orated during this drive, none of them attained the lavishness of New York. The
city's decorations of Allied flags came to symbolize the entire national war
effort.[63]

The term "Avenue of the Allies" originated in September 1918 because of
the truly international nature of the flag display along Fifth Avenue during the
Fourth Liberty Loan Drive. The president of the Fifth Avenue Association
underscored this point: "Our own Fifth Avenue, the whole city's Fifth Avenue,
aye the Nation's Fifth Avenue, now for the time being proudly bearing the
name of 'The Avenue of the Allies,' has a privilege and a glory of service in these
times which must stir all our hearts."[64] Hassam used the title *Avenue of the Allies*
five times, applying the term specifically to the paintings that depict the Fourth

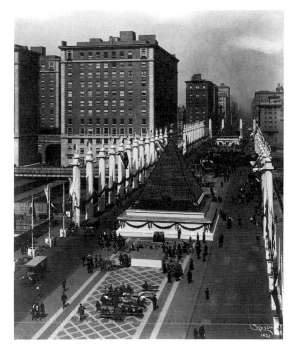

Liberty Loan flag displays (pls. 20–24). He faithfully depicted the elaborately orchestrated decorations so that, based on the configurations of the banners, each site is identifiable. The different flags are emphasized by means of their large scale and the clear lighting. In each case Hassam chose a low viewpoint and slightly tilted up the ground plane not only to stress the flags but also to enable a vista of banners to be seen. He distinguished the exact block represented by using a subtitle or parenthetical phrase referring to the flags that were hanging. For example, *Avenue of the Allies: France, 1918 (the Czecho-Slovak Flag in the Foreground, Greece beyond)*, 1918 (pl. 20), is a view of Fifth Avenue between Forty-eighth and Forty-seventh streets, looking south to Forty-fifth Street, and *Avenue of the Allies, 1918 (Allied Flags in Front of Saint Patrick's Cathedral, Service Flag on Union Club, China, Great Britain, Belgium beyond)*, 1918 (pl. 22), is a view from Fiftieth Street, looking north to Fifty-fourth Street in the distance.

The unusual configuration of national flags and brilliant red pennants enables the identification of Theodore Earl Butler's *Flag Day*, 1918 (fig. 25), as a Fourth Liberty Loan Drive display. Butler's painting does not refer to the June 14 holiday but to a day in October 1918, as confirmed by the inscription after the artist's signature.[65] The painting depicts the same national flags as Hassam's *Avenue of the Allies: Brazil, Belgium, 1918*, 1918 (pl. 24). Hassam faithfully recorded the flags of the British Empire, Belgium, and Brazil, with the United States flag in the distance, as if seen by a spectator standing on Fifty-third Street looking north. Butler depicted the view looking in the opposite direc-

Fig. 26
Underwood and Underwood
Panels in front of the New York Public
Library for Red Cross Christmas Roll Call,
December 1918
The National Archives, Washington, D.C.

Fig. 27
Crossman
Photograph of Victory Way, 1919
Photography Collection, Miriam and
Ira D. Wallach Division of Art, Prints and
Photographs, The New York Public
Library, Astor, Lenox and Tilden
Foundations

25

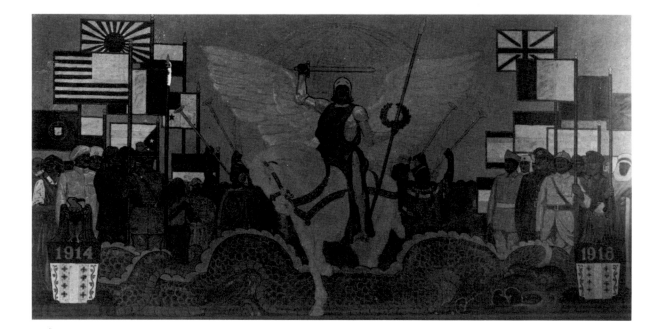

tion, deviating slightly from an accurate depiction by reversing the order of the flags of the British Empire and Brazil.[66]

Images by other artists can also be associated with specific days or events. In *The Bersaglieri,* 1918 (National Gallery of Art, Washington, D.C.), Luks depicted the Italian squadron, the Bersaglieri, which came to New York especially to participate in a variety of Liberty Loan events on October 3. Hayley Lever painted the French Day celebrations on Fifth Avenue held on October 4.[67]

Although the war ended on November 11, 1918, a few weeks after the close of the Fourth Liberty Loan Drive, money was needed to bring the troops home and to assist with the reconstruction of a devastated Europe. Planning began for the Fifth Liberty Loan Drive, better known as the Victory Loan Drive, held from April 21 to May 10, 1919. Because New York was the major debarkation point for the returning armed forces, the city welcomed them home with pageantry during the winter and into the spring of 1919. During the 1918 Christmas season a group of New York artists assisted the American Red Cross in celebrating its Christmas Roll Call Week (December 16–23). In addition to a block party, flag decorations, and illuminated "arches of mercy," there was a display of paintings that surpassed in size and variety the Fourth Liberty Loan window display.[68] Approximately 140 paintings, each seven by ten feet, were especially painted and placed before the fronts of buildings on Fifth Avenue from Twenty-sixth to Fifty-eighth streets. Illustrated panels were set up in front of the New York Public Library (fig. 26). Although all the paintings symbolized the activities of the Red Cross, they represented a wide variety of aesthetics.

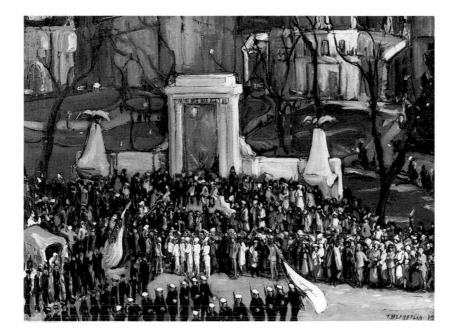

Not only were the usual illustrators and academic artists represented but even such modernists as Arthur B. Davies, Gaston Lachaise, Joseph Stella, Maurice Stern, Max Weber, and William Zorach. The artists of the Penguin Club, with Walt Kuhn directing, were instrumental in organizing the pictures, and the club's headquarters served as a studio for many of the artists.[69]

On November 30, 1918, the Mayor's Committee on National Defense ceased to exist, and a week later the Mayor's Committee of Welcome to Homecoming Troops was formed, with sculptor Paul W. Bartlett and architect Thomas Hastings serving as the art committee on the executive board.[70] So elaborate were the planned activities that separate committees were formed for decorations, illuminations, and pageants. There were special parades and receptions for the returning New York regiments, at least one a month, from February to May of 1919. Fifth Avenue from its extreme south end at Washington Square to the northern tip of Central Park at 110th Street was repeatedly decorated "in order that the depth of the City's appreciation of its homecoming warriors might be properly typified," and again the avenue was a "riot of motion and color."[71] At night the avenue was converted into a Golden Way with amber-tinted electric lamps installed from Washington Square Arch to Sixtieth Street.

On the site of the Dewey Arch of 1899, next to the Altar of Liberty, a temporary Victory Arch was erected, through which the returning soldiers marched. The arch was designed by Hastings, and its decorative reliefs and freestanding sculptures were the work of twenty-eight artists.[72] In front of the New York Public Library a Court of the Victorious Dead was installed with a

Fig. 29
Theresa Bernstein (United States, born 1886)
ARMISTICE DAY CELEBRATION. 1919
Oil on canvas
30 x 40 in. (76.2 x 101.6 cm.)
Janet Marqusee Fine Arts Ltd., New York

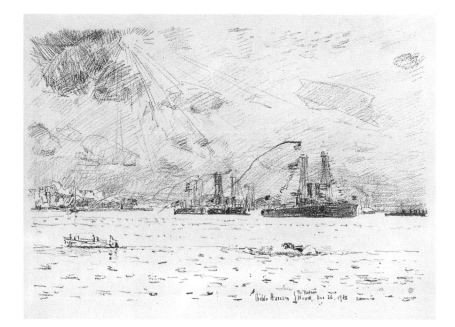

Roll of Honor and a display of trophies—shields, lances, rifles—the traditional emblems of battle. In addition, a special Jeweled Portal (also known as the Arch of Jewels) of glass prisms illuminated with thousands of incandescent lights was constructed on Fifth Avenue and Sixtieth Street at Central Park. This was intended to be "a piece of decorative lighting entirely new and surpassing anything which had ever been made. The Portal in its conception was symbolic of the Living Light of Democracy triumphant over the darkness and evil of militarism."[73] Although triumphal arches had a long history going back to ancient times, electrical illumination for dramatic nighttime viewing was a modern addition to victory celebrations. Despite the uniqueness of some of the displays, at least one writer still found the flag decorations along Fifth Avenue the most successful of the civic decorations.[74]

During the Victory Loan Drive, Park Avenue was transformed into Victory Way with rows of captured German guns, pyramids studded with spikes from German helmets, and garlanded columns (fig. 27). A speaker's stand, used for day and evening events, was constructed between Forty-seventh and Forty-eighth streets. Behind the stand a mural frieze of seven panels, entitled *The Continents of the Earth Contributing to Victory*, ran 160 feet in length. Each panel was created by a different artist, but all worked in collaboration on a single general scheme. The central panel, *The World Victorious*, 1919, by Arthur Crisp (fig. 28), as well as the other six devoted to different continents, depicted symbolic figures in the turn-of-the-century Beaux-Arts mural aesthetic.[75]

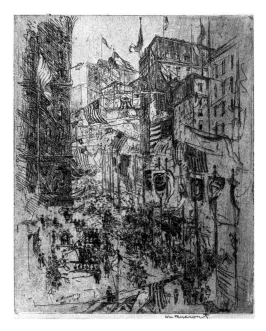

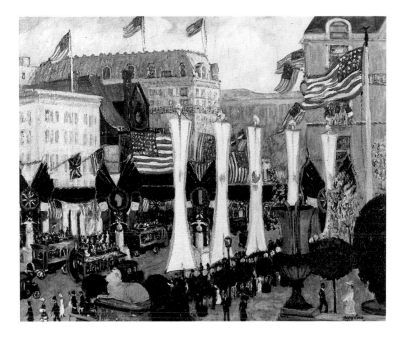

If the quantity of art is any indicator, of all the war celebrations the armistice and victory celebrations were the most appealing to artists, who were joyful over the peace and the return of American troops. Theresa Bernstein expressed such a sentiment as one of the primary reasons she repeatedly painted the victory parades (fig. 29).[76] In December 1918 Hassam must have had similar feelings when he drew *Return of the Fleet* (fig. 30), which shows one of the first ships to arrive back in New York. Luks and Butler painted the crowds at the first armistice celebrations, both capturing in nighttime images the electricity of the city rejoicing (figs. 43–44).

Many artists depicted the festivities that took place around the New York Public Library: William Meyerowitz commemorated Armistice Day in an etching (fig. 31), and Hayley Lever depicted a later celebration, watching the festivities from behind special large white victory banners that decorated the library's entrance (fig. 32). Hassam, as before, painted none of the parades. His two versions of *Saint Patrick's Day*, both painted in 1919, are the antitheses of celebratory works (figs. 41–42). A quiet, somewhat empty street is depicted in the rain, with only a few flags adding a patriotic note. He did dedicate one canvas, *Victory Won*, 1919 (pl. 25), to the concept of victory, returning to a more dramatic scene with Fifth Avenue in a flurry of triangular victory banners and United States flags. But the scene is set in early morning before any of the official festivities have begun.

The "Allied War Salon" opened on December 9, 1918, several weeks after

the armistice, providing the public with an accurate overview of the art created in response to the war. The show was organized by Duncan Phillips, Gallatin, and Tack and sponsored jointly by the Division of Pictorial Publicity of the Mayor's Committee on National Defense and the American Federation of Art. Held at the American Art Galleries, the exhibition included more than six hundred paintings, sculptures, prints, drawings, and posters by artists from the United States and five other Allied nations. Among the more notable works shown were Bellows's *Murder of Edith Cavell*, 1918 (Museum of Fine Arts, Springfield, Massachusetts); Luks's *Czecho-Slovakian Army Entering Vladivostok, Siberia, in 1918*, 1918 (Los Angeles County Museum of Art); Melchers's *A Scotch Drummer*, 1918 (Art Gallery of Ontario, Toronto); and Pennell's series of war prints. Hassam exhibited six prints and possibly two flag paintings, *Early Morning on Fifth Avenue*, 1917 (pl. 11), and *Allied Flags, April 1917*. The latter had only recently been on view at two special war exhibitions: in Connecticut at the Mystic Art Association's summer exhibition, held as a benefit for the Red Cross, and in a special patriotic display at the Cleveland Museum of Art that autumn. [77]

These were not the only times Hassam exhibited his flag paintings. During the period of America's involvement in the war he showed a number of war-related paintings, singly and in groups. The first flag painting that seems to have been displayed was called *Fifth Avenue, Fourth of July* (probably pl. 2), shown in the spring 1917 annual exhibition of the National Academy of Design. During the summer of that year *Allied Flags, April 1917* was included in a group exhibition at Knoedler. In 1918 Hassam showed his paintings in increasing numbers. *To the 101st (Massachusetts) Infantry*, 1918 (fig. 39), was placed in the National Academy's winter 1918 annual. A short time later he exhibited *Flags at the Waldorf*, 1917 (probably pl. 10), and *Fifth Avenue Flags*, 1916 (identity unknown), along with two earlier scenes with related themes—*Paris: July 14th*, 1889 (probably *Fourteenth July, Paris, Old Quarter*, 1887–89 [Museum of Art, Carnegie Institute, Pittsburgh]) and *Montmartre, July Fourteenth*, 1889 (possibly fig. 33)—at the 113th annual of the Pennsylvania Academy of the Fine Arts, Philadelphia. [78] He contributed *Allies Day, May 1917* and *New York Landscape* to the spring annual of the National Academy. The former was awarded the Altman Prize for landscape painting and achieved almost instant popularity. His largest showing during the war was part of a group exhibition at Montross Gallery, New York, which opened in April 1918; he exhibited five paintings, including the two flag compositions recently shown in Philadelphia. [79]

Despite these exhibitions the American public had no opportunity to realize the scope and nature of Hassam's flag paintings until November 1918. A few days after the armistice the artist presented his flag paintings as a series for the first time in a special exhibition at the New York galleries of Durand-Ruel. Twenty paintings of views of New York with flags were included, and only in such a large grouping could the full range, variety, and meaning of Hassam's paintings be fully appreciated.

THE FLAG PAINTINGS

1

JUST OFF THE AVENUE,
FIFTY-THIRD STREET, MAY 1916
1916
Oil on canvas
31¼ x 26½ in. (79.4 x 67.3 cm.)
Mr. and Mrs. Richard J. Schwartz

This is the earliest-dated flag painting Hassam created during World War I. It depicts Fifty-third Street just west of Fifth Avenue, a locale that was to become well known as the site of the Museum of Modern Art, which opened in 1939. During the 1910s this block was noted for its handsome brownstone houses, only a few of which now remain. The street is viewed obliquely from the southeast corner of Fifty-third Street and Sixth Avenue, looking toward Fifth Avenue. In the distance the tower of Saint Thomas's Episcopal Church, on the northwest corner of Fifty-third Street and Fifth Avenue, dominates the skyline and forms a soft, pastel contrast to the brilliant spring foliage in the foreground.

During the early years of the war, before the United States entered the conflict, New York was occasionally decorated with flags for special celebrations, and Hassam stated that it was the displays of Preparedness Day on May 13, 1916, that initially inspired him to begin the flag paintings. Unlike his later flag images, in which Hassam depicted the elaborate displays that bedecked Fifth Avenue, here he chose a more modestly decorated side street. Only one Stars and Stripes is clearly delineated in the middle distance. However, Hassam hinted at the inclusion of other United States flags, hidden behind the heavy foliage, through the pink and red strokes in the near and distant trees.

The clear, light blue sky indicates a sunny spring day. The colors of the buildings reflect the effect of brilliant sunlight: the purplish blue tone of the brownstones in the foreground shadows, the whiter blue of the church tower, and an opalescent array of colors for the sparkling stone office building in full sunlight across the street on Fifth Avenue.

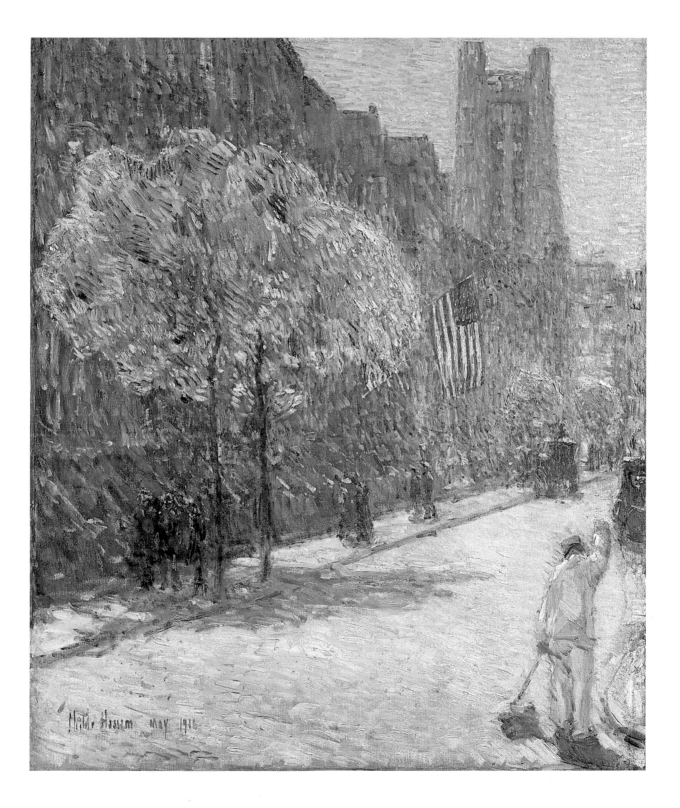

*THE FOURTH OF JULY, 1916
(THE GREATEST DISPLAY OF THE
AMERICAN FLAG EVER SEEN IN
NEW YORK, CLIMAX OF THE
PREPAREDNESS PARADE IN MAY)*
1916
Oil on canvas
36 x 26 in. (91.4 x 66 cm.)
Collection of
Mr. and Mrs. Frank Sinatra

As elaborate as the decorations for the Preparedness Parade had been in May 1916, they were surpassed by those installed for the annual Fourth of July celebrations. Hassam's painting is indeed a glorious tribute to the American flag and was immediately noted as such when it was exhibited in 1917 at the Montross Gallery in New York: "Then comes the climax, that fairly shouts hurrah for Old Glory! 'The Fourth of July-Fifth Avenue' — a sea of stars and stripes floating to the breeze from the tall buildings on either side of the great American thoroughfare. And even this enthusiasm is kept within the ordered restraint of an art ever true to its sense of color relations and atmospheric harmony."[1]

This painting is one of only two summer scenes in the flag series. However, Hassam did not convey the sense of glaring sunlight or oppressive humidity that characterizes New York summers. Rather he infused the scene with an airy lightness that is similar to his interpretation of the flag motif in spring. The sky is light blue and filled with large cumulus clouds. The flags, especially the ones high up, move briskly in the breeze. The red, white, and blue colors of the United States banner establish the overall palette, as they do in most of the flag paintings from the years 1916 and 1917.

Hassam's handling was quick and vigorous throughout. In the flags he used long strokes for the stripes and dabs for the stars. The buildings were barely sketched in with long, dry strokes of whites, pale blues, and lavenders. This impressionist brushwork makes it impossible to identify the exact site, although it is surely a view of Fifth Avenue, which was already known for its skyscraper-dominated skyline and green double-decker buses.

1. *"New York Art Exhibitions and Gallery Notes,"* Christian Science Monitor *clipping, 1917, Hassam Papers (microfilm, roll NAA-1, fr. 566).*

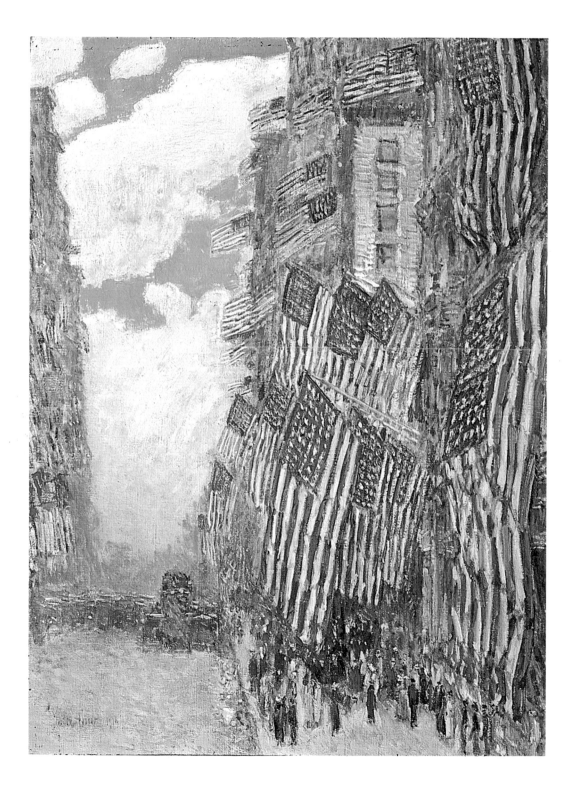

FLAGS ON THE WALDORF, 1916
1916
Oil on canvas
36¼ x 30¼ in. (92.1 x 76.8 cm.)
Amon Carter Museum,
Fort Worth, Texas

Designed in the 1890s by New York architect Henry J. Hardenbergh, the original Waldorf-Astoria Hotel extended along the west side of the entire block on Fifth Avenue from Thirty-third to Thirty-fourth streets. Demolished in 1929 to make way for the Empire State Building, the hotel was a well-known structure, often photographed from the southeast corner of Thirty-second Street, with the neoclassical facade of the Knickerbocker Trust and Safe Deposit Company in the background on the northwest corner of Thirty-fourth Street (fig. 52). Hassam would later use such a viewpoint in *Avenue of the Allies,* 1917 (pl. 10). For *Flags on the Waldorf, 1916* he chose a less typical vantage point, looking south from the west side of Fifth Avenue midway between Thirty-fifth and Thirty-fourth streets. He omitted Thirty-fourth Street, a large cross street, so that the hotel and bank seem to form a continuous, massive wall.

Hassam also excluded the Flatiron Building, which otherwise would be seen in the far distance. This triangular building at Twenty-third Street was one of the most famous in New York, and its unusual silhouette often appeared in similar views by artists of the period, including Hassam (fig. 1). Its omission enabled Hassam to open up the distant sky. By excluding both Thirty-fourth Street and the Flatiron Building, the artist intensified the feeling of the avenue as a long, narrow canyon.

There are countless United States flags hanging from all levels of the buildings along the avenue, with only the three flags on the hotel facade presented on a grand scale. Such a display—primarily large groupings in which individual banners are difficult to distinguish—was typical of Hassam's early interpretation of the flag motif.

The deep blue and white colors of the flags are repeated in the hotel facade, with the blue establishing the basic cool, damp tonality of the overall scene. The clearing sky and zigzag brushstrokes in the foreground, which suggest a wet street, also contribute to the feeling that a rainstorm may have just ended.

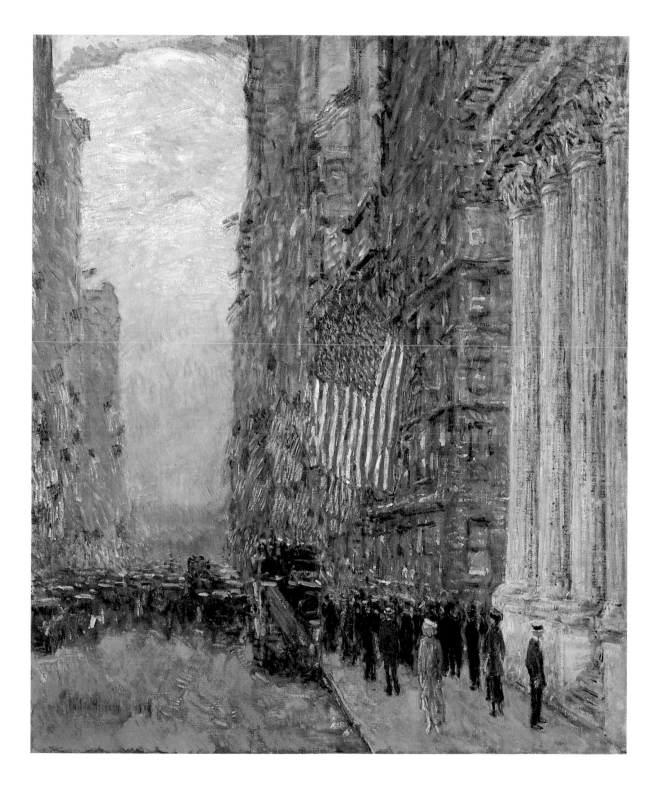

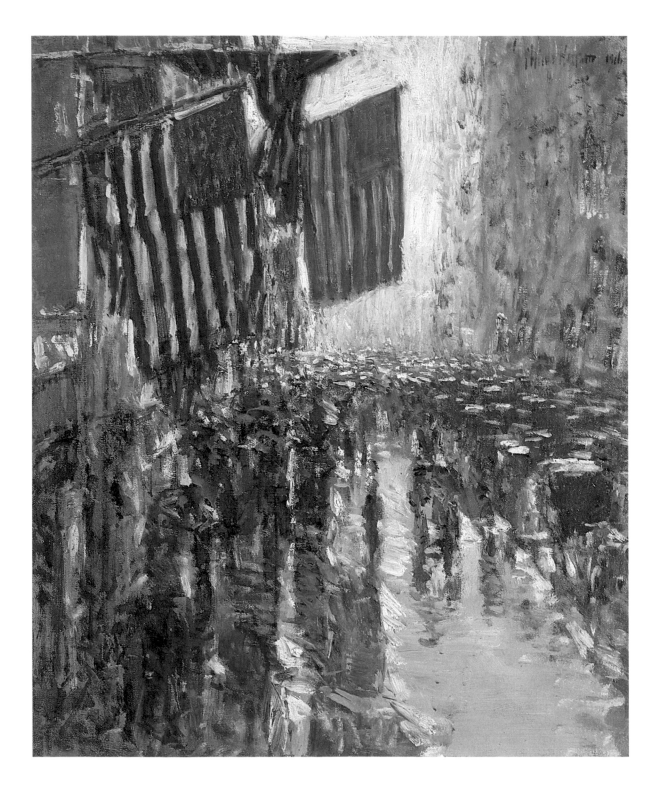

Although not exhibited in the flag series, this painting relates thematically and conceptually to the series. Because of its unfinished, sketchy quality Hassam might have considered the painting more of an experiment. It serves as a link between his early, very impressionistic flag images concerned with weather and the later, more iconic paintings that emphasize the flag as emblem.

This work differs from the series paintings in two aspects: underpainting and size. Unlike the canvases in the series, which usually have a ground, or first layer, in white, off-white, or gray, this work has a colored underpaint, which is seen throughout because of the looseness of the handling. French impressionists often used canvases that were unprimed or painted white to intensify the brilliance of their light effects. The khaki-green underpaint that Hassam used here creates the opposite effect. The overall toned-down impression establishes a gloomy mood for the damp, rainy-day scene despite the abundance of blues and warm reds. Hassam chose the same colored underpaint and achieved a similar somber effect in only one other flag painting, *Avenue of the Allies,* 1917 (pl. 10). These two canvases also are the same size, eighteen by fifteen inches—a format much smaller than any of Hassam's other flag paintings. The two works might have been done about the same time, the winter of 1916–17.

RAINY DAY, FIFTH AVENUE, 1916
1916
Oil on canvas
18 x 15 in. (46 x 38.5 cm.)
The Art Museum,
Princeton University, New Jersey

5

THE AVENUE IN THE RAIN, 1917
Also known as
FLAG DAY
1917
Oil on canvas
42 x 22¼ in. (106.7 x 56.5 cm.)
The White House

This is a quintessential impressionist painting as well as one of Hassam's most stirring patriotic images. A single, huge United States flag dominates the rainy street scene, and smaller banners are repeated endlessly down the avenue. Although the inclement weather blurs details, it also multiplies the number of flags seen, as they are reflected on the wet pavement below.

This painting is an optimistic proclamation of America's glory. Contrary to the usual somber mood of a rainy-day image, an upbeat feeling is established in this work by the red, white, and blue colors of the flag. Although Hassam added a great deal of white to the hues, the colors remain intense: reds range from brilliant crimson to soft pink, and blues from deep cobalt to warm mauve. The richness of the palette tends to be somewhat sweet, more so than in any of the other flag images, and as a result it conveys a sense of harmony.

Although the painting is signed February 1917, it was repeatedly shown in the flag-series exhibitions with the date of 1916. The confusion may have resulted from the incorrect label that remains on the back of the canvas stretcher.

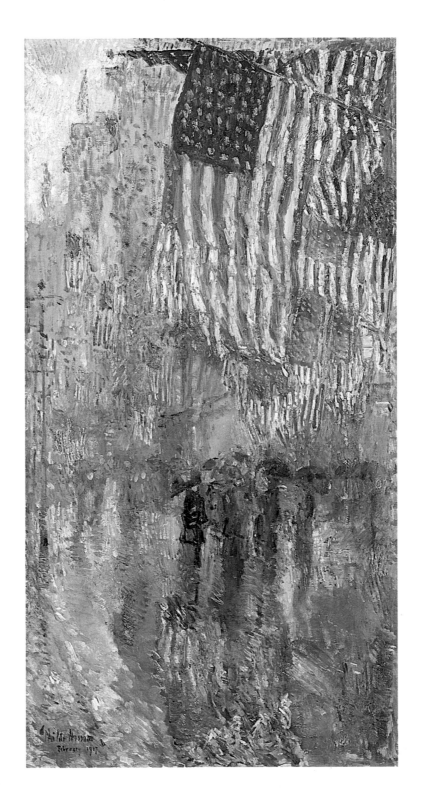

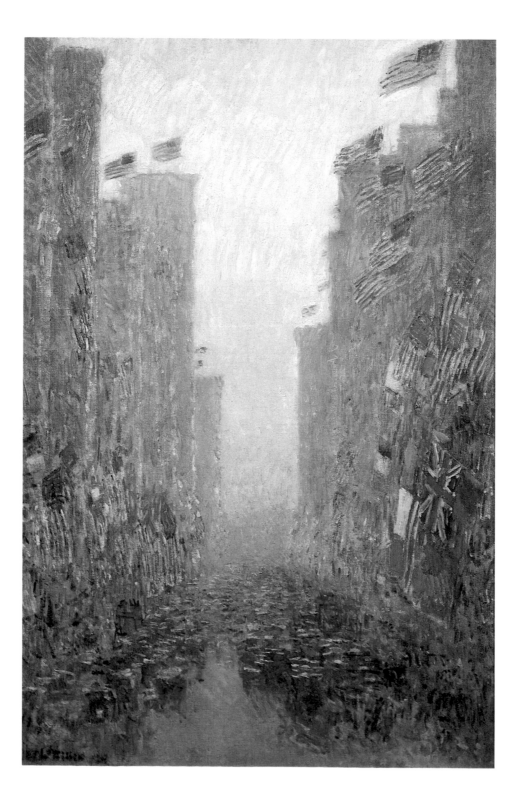

Hassam has cast Fifth Avenue, with its line of skyscrapers, in soft, atmospheric veils. Nothing is clearly delineated; all appears indistinct and intangible. The title places the time of day as afternoon, and the twilight hour may partly account for the shadowy haze. Hassam's handling, ranging from transparent washes to thick dabs of pigment and passages of impasto, contributes substantially to the effect. The result is one of the supreme impressionist paintings of the flag series.

The entire image shimmers with opalescent hues. In its palette the painting is closest to *The Avenue in the Rain, 1917,* 1917 (pl. 5), although not as sweet. Hassam built up the skyscrapers from strokes of variegated tints applied over a soft, almost rubbed field of blue. The street traffic, indicated by heavy paint applied over a deep purple wash, appears equally indistinct. Despite the vagueness, the national flags emerge from the overall impression.

Although the exact month in which this painting was done is unknown, it may be one of the first flag paintings Hassam created after the United States entered the war. The inclusion of a few British, French, and Italian flags among the plethora of United States banners suggests that the painting was more likely done during or after the war commissioners of the major Allied nations began visiting the United States, that is, in May 1917 or later. However, the extreme impressionist handling links the work to Hassam's earlier flag images.

AFTERNOON ON THE AVENUE, 1917
Also known as
FLAGS, AFTERNOON ON THE AVENUE
1917
Oil on canvas
36 x 24 in. (91.4 x 61 cm.)
Mr. and Mrs. Thomas M. Evans

ALLIED FLAGS, APRIL 1917
Also known as
ALLIED FLAGS, UNION LEAGUE CLUB
1917
Oil on canvas
30½ x 49 in.
(77.5 x 124.5 cm.)
Kennedy Galleries, New York

The Union League Club was established during the Civil War and by the end of the nineteenth century was a prominent men's club. Designed by Peabody and Stearns of Boston and opened in 1881, the clubhouse was situated on the northeast corner of Fifth Avenue and Thirty-ninth Street. A Queen Anne-style, slate and brick building of warm red with brownstone trimming, it exemplified luxury and privacy. The main entrance was on the side street; the Fifth Avenue facade consisted of large windows and a balcony.

This painting—the largest canvas in the series—is the only flag scene in which Hassam chose not to depict a site obliquely. He painted the clubhouse from the windows of the Macbeth Gallery, located directly across the street on Fifth Avenue.[1] This vantage point offered the fullest view of the balcony, which was used during World War I as a reviewing stand and from which flags were hung. Hassam's desire to present the flags as clearly as possible accounts for his viewpoint and for his moving in close and cropping off the roof line.

Painted about the time of America's entry into the war, this is the first flag painting in which Hassam included the banners of so many Allied nations. They are presented in a line and represent, from left to right, Japan, Portugal, Belgium, Italy, Great Britain, France, the red flag of revolutionary Russia, Cuba, Serbia, Brazil, and Romania.[2] The difficulty in reading some of the flags may be attributed to the way they were hung around the balcony and over the architectural trimming. Hassam also took liberties with the colors and emblems of the Portuguese and Brazilian flags.

The banners make up a colorful and decorative array more varied than those in most of the flag paintings, in which only red, white, and blue dominate. The red-brown slate wall sparkles with touches of warm hues as afternoon sunlight illuminates the building. With an American flag flying separately above the others, the painting symbolizes the country's entry into the war.

In the center foreground Hassam inscribed his initials above the head of the pedestrian carrying a green artist's portfolio. By including himself as a figure within the scene, he suggested that he was an actual participant rather than just a recorder of home-front activities.

This appears to have been the flag painting exhibited most often during the war. In the summer of 1918 Hassam sent it to Connecticut for the Mystic Art Association's fifth annual exhibition, a benefit for the Red Cross. Immediately thereafter it was lent to the Cleveland Museum of Art, where it became a central part of that institution's Fourth Liberty Loan celebrations. It was exhibited as part of the flag series only at the Corcoran Gallery of Art in 1922.

1. *Robert Macbeth to Frederic Allen Whiting, director, Cleveland Museum of Art, August 21, 1918. Macbeth Gallery Papers (microfilm, roll 2580, fr. 788).*
2. *Macbeth to Whiting, September 26, 1918. Macbeth Gallery Papers (roll 2580, frs. 803–4). Macbeth identified the red flag, noting that it was in existence for only a short time. The provisional Russian government that was established after the overthrow of the czar in February 1917 did not officially adopt any flag. A solid red banner had long been identified with Russian radicals and therefore might have been used in an Allied display to represent the new government.*

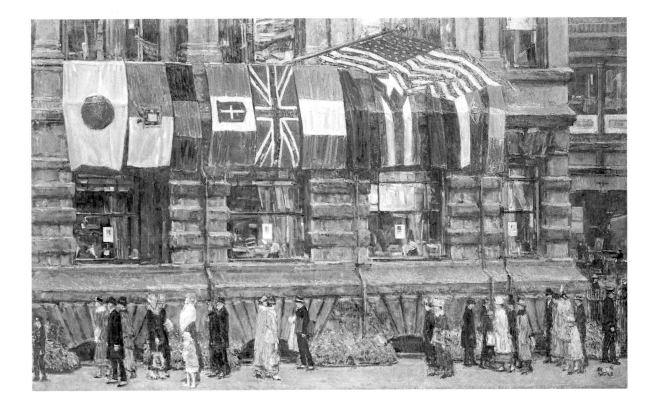

ALLIES DAY, MAY 1917
1917
Oil on canvas
36¾ x 30¼ in. (93.5 x 77 cm.)
National Gallery of Art,
Washington, D.C.
Gift of Ethelyn McKinney in memory
of her brother, Glen Ford McKinney

During May 1917 Hassam created the first concentrated group of flag paintings. In the months immediately following the United States entry into World War I, the Allied war commissioners visited New York and Washington, D.C. New York gave each commissioner an official welcome that included receptions and parades and decorated the city in their honor. This painting represents "the historic scene…when the flags of Great Britain and of France were first hung with the Stars and Stripes and the streets were thronged to greet General [Joseph-Jacques-Césaire] Joffre and Mr. [Arthur James] Balfour, emissaries of the new comradeship between nations."[1] Joffre and Balfour visited New York on May 9 and 11, respectively. The date inscribed on the painting has traditionally been read as May 17, 1917, although Hassam's numbers in particular tend to be difficult to read. In fact the entire month of May was devoted to celebrating Anglo-French-American cooperation, and Hassam dedicated this painting "to the British and French nations commemorating the coming together of the three peoples in the Fight for democracy."[2]

The three Allied flags are seen in groupings throughout the scene. Viewed from a high vantage point, the banners form a protective canopy over the street life below. The scene shows Fifth Avenue, to the north with Saint Thomas's Episcopal Church in the middle distance on the left and the University Club, Gotham Hotel, and a glimpse of the Fifth Avenue Presbyterian Church beyond. Morning sunlight illuminates the buildings on the avenue's west side, so they sparkle in a variegated range of pastel hues. Saint Thomas's is especially bright and forms a stunning visual counterpart to the deeper hues of the flags. The color and light metaphorically suggest that the new union of Allies has divine blessings.

Although never part of the series, this is Hassam's most famous flag painting. It immediately became well known upon being shown at the National Academy of Design's ninety-third annual exhibition in the spring of 1918, where it won the Altman Prize for landscape. Frequently reproduced in color in a number of publications about New York or the war, it served as the frontispiece for Alfred Noyes's book of poems *The Avenue of the Allies and Victory* (1918). Reproductions, along with copies of Noyes's book, were sold for the Art War Relief fund. In November 1919, at the annual dinner of the Fifth Avenue Association, an autographed color reproduction was auctioned for nineteen hundred dollars, with the proceeds benefiting children's reading rooms in France and Belgium.[3] Acquisition of the painting in 1943 by the National Gallery of Art intensified its association as a national image.

1. *Griffiths and Hitchcock, in Noyes,* The Avenue of the Allies and Victory, *p. 7.*
2. *Frontispiece, ibid.*
3. *"Hassam Print Brings $1,900,"* American Art News 18 *(November 15, 1919): 1.*

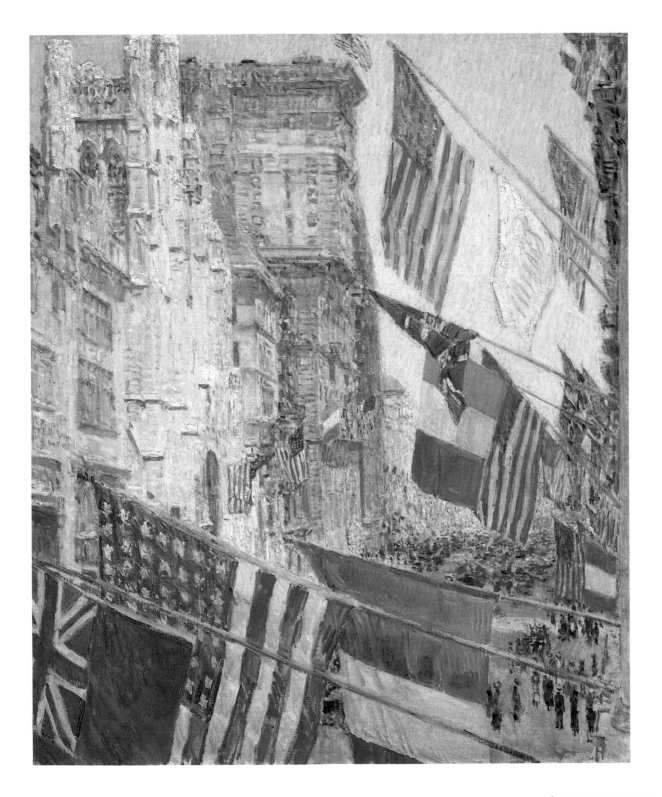

*UP THE AVENUE FROM
THIRTY-FOURTH STREET, MAY 1917*
Also known as
FLAGS, FIFTH AVENUE
1917
Oil on canvas
36 x 29¹⁵/₁₆ in. (91.4 x 76.1 cm.)
Private collection

Given the general title *Flags, Fifth Avenue* when it was owned by the Milch Galleries, this painting was exhibited as *Up the Avenue from Thirty-fourth Street, May 1917* at the Durand-Ruel showing of the series.

The south corner of B. Altman and Company's Italianate building at Thirty-fourth Street forms the right edge of the composition, with the view leading farther up Fifth Avenue. Altman's was the first major department store in the area, erecting its limestone building in 1906. Up the avenue on the left at Thirty-seventh Street is the dark brown, Gothic-style Brick Presbyterian Church designed by Leopold Eidlitz.

During May 1917, when British and French war commissioners first visited New York, displays began to represent the Anglo-French-American alliance. French and British flags appeared in profusion along with the Stars and Stripes, although the latter was still the most numerous. As if in response to the new political situation Hassam transformed his interpretation to afford an accurate reading of the different national banners. He experimented with an elevated perspective in *Allies Day, May 1917,* 1917 (pl. 8), and in this painting, so that the viewer is placed closer to the flags, with the banners in the foreground appearing as distinct entities rather than as colors blurred in a large grouping.

Although an annotated copy of the 1918 Durand-Ruel exhibition catalogue lists the painting as sold, it was not purchased until at least the following year.[1] The work was again on view as part of the series exhibition at the Carnegie Institute, Pittsburgh, during the early spring of 1919.

1. *In Hassam Papers (microfilm, roll NAA-2, fr. 386).*

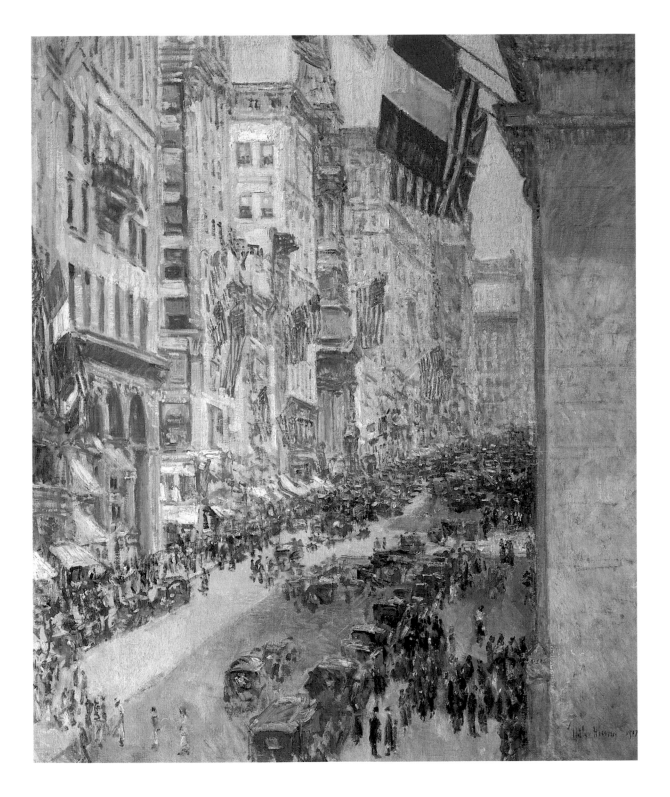

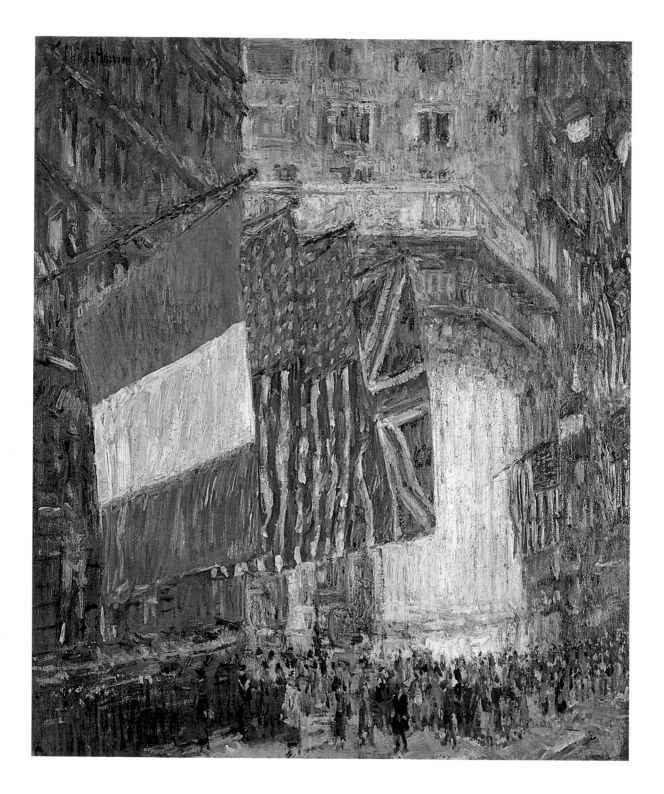

The original title of this painting is not known, but the work itself definitely predates the reference to Fifth Avenue as Avenue of the Allies, which did not come into use until September 1918. The present title, *Avenue of the Allies,* was probably applied sometime after November 1918, when Hassam's flag series was first identified with this avenue.

Never exhibited as part of the series, this painting differs in two substantial ways from any of the canvases in the series: it is much smaller and has a khaki-green underpaint. It shares both characteristics with *Rainy Day, Fifth Avenue, 1916,* 1916 (pl. 4), and the two paintings possibly reflect experimentation Hassam was pursuing in the winter of 1916–17. In typical impressionist fashion, he usually worked on an unprimed canvas or one with an underpaint of white or off-white. Here the muted green underpaint tones down the scene, so that it appears to be an overcast day despite no indication of inclement weather in the sky.

The view is of the Waldorf-Astoria Hotel and the Knickerbocker Trust and Safe Deposit Company, as seen from the southeast looking north toward Thirty-fourth Street. These two landmark buildings were popular photographic subjects, and Hassam's interpretation is more characteristic of contemporary photographs of them (fig. 52) than the vista he presented in the earlier *Flags on the Waldorf, 1916,* 1916 (pl. 3). Whereas the photographs usually include the entire Fifth Avenue facade of the hotel, in *Avenue of the Allies* Hassam cut off the building, focusing on the flags rather than the structure. As was typical of the decorations in 1917, the United States flag is grouped with those of its major allies, France and Great Britain.

AVENUE OF THE ALLIES
Also known as
FLAGS ON THE WALDORF
1917
Oil on canvas
18 x 15 in. (45.7 x 38.1 cm.)
Telfair Academy of Arts and
Sciences, Inc., Savannah, Georgia
Bequest of Elizabeth Millar
Bullard, 1942

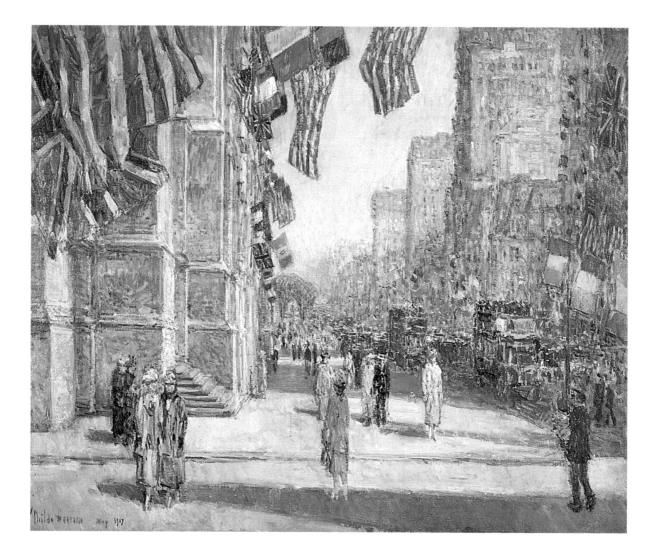

The illustration of this painting in a *New York Tribune* article about Hassam's flag paintings identifies it as *Early Morning on the Avenue*.[1] By February 1919 it was known as *Avenue of the Allies* and illustrated as such in the *American Magazine of Art*.[2] The title change alludes to the name with which Fifth Avenue became identified as a result of the Fourth Liberty Loan Drive in 1918. It was also the title given to Hassam's series when first exhibited at Durand-Ruel in November 1918. However, this scene predated the existence of the term "Avenue of the Allies" by more than a year.

For this painting Hassam stood on the southwest corner of Fifty-third Street and Fifth Avenue, directly opposite the side of Saint Thomas's Episcopal Church, the large structure on the left. Hassam included Saint Thomas's in several flag paintings (pls. 1, 8, and 22), but this is the only one in which the church is presented at such close range that its identity is all but obscured. Although the composition is atypical of the paintings in the flag series, Hassam used it in *Fifth Avenue, Noon,* 1916 (fig. 56), one of his most famous prints of New York.

The large flags in the upper-left corner serve as a *repoussoir* device, leading the viewer into the scene and establishing the context of the pedestrian activity. Hassam represented Fifth Avenue as it was decorated during the many celebrations welcoming Allied war commissioners to the United States in the spring of 1917. The French tricolor and the British Union Jack appear in profusion, often grouped with Old Glory.

The painting conveys an upbeat, almost celebratory feeling, even though Fifth Avenue is filled with ordinary pedestrian and street traffic. This mood is attained by the clarity and warmth of the light and the color intensity of the flags. The long shadows indicate that it is early morning. The air is brisk and crystalline, the distant sky almost white. The flags are stirred by the wind and illuminated by the sun. Hassam added strokes of yellow to the flags to intensify the sense of sunlight and warmth.

This was the only flag painting sold at the Durand-Ruel exhibition of the series.

1. *"Flags and the Man Who Paints Them," p. 3.*
2. *Duncan Phillips, "The Allied War Salon,"* American Magazine of Art 10 (February 1919): *122.*

EARLY MORNING
ON THE AVENUE IN MAY 1917
Also known as
AVENUE OF THE ALLIES
1917
Oil on canvas
30¹⁄₁₆ x 36³⁄₁₆ in. (76.3 x 91.9 cm.)
Addison Gallery of American Art,
Phillips Academy, Andover,
Massachusetts
The Candace C. Stimson Bequest

THE NEW YORK BOUQUET:
WEST FORTY-SECOND STREET, 1917
1917
Oil on canvas
35⅜ x 23⅜ in. (89.9 x 59.4 cm.)
Mr. and Mrs. Hugh Halff, Jr.

This is one of the few paintings in the series depicting a location off Fifth Avenue and the only one of Forty-second Street. Already a major thoroughfare with notable skyscrapers, such as the Times Square Building and the Astor Trust Building, Forty-second Street formed the northern boundary of Bryant Park. Numerous war-related activities took place in the park and in front of the New York Public Library, situated on the Fifth Avenue side of the park.

A *New York Times* writer stated that "perhaps no area of corresponding size, outside the actual war zone, bears so many reminders of the war as Bryant Park."[1] However, Hassam never recorded any of these activities, and for this painting he faced west with the park barely visible on his left. In the distance are a station of the Sixth Avenue elevated train line and the Bush Terminal Building, which rises majestically above the other buildings. The highest structure along Forty-second Street from Fifth to Seventh avenues, this skyscraper was being completed about the time Hassam painted it. His depiction deviates from the actual building in some details—most notably the omission of a side staircase—and might have been based on the plans of architects Helme and Corbett rather than on the finished structure. The skyscraper fills most of the composition's left side.

The flags occupying the right side of the composition are probably flying from Aeolian Hall, which was midway between Fifth and Sixth avenues. The French flag is shown in its entirety, moving in a gentle wind, but the banners of Great Britain and the United States are partially hidden behind it. A service flag, cropped by the edge of the canvas, is only partly seen. The flags contribute the most vivid colors to the scene, vying for attention with the Bush Terminal Building because of their size and placement.

The title's reference to a bouquet suggests a springtime view, but this sunny scene is a cold day in autumn, as indicated by leafless trees, a clear, light blue sky, and a sense of crisp air. The season is confirmed by the inscription "Nov. 14, 1917" on the lithograph of the same title.[2] The bouquet Hassam referred to might have been the Bush Terminal Building. During the early years of the twentieth century when skyscrapers were still new, descriptions of them often alluded to similarities with natural phenomena. Henry James described New York's skyline as a "loose nosegay of architectural flowers," with the tall buildings being the "'American beauty,' the rose of interminable stem."[3]

1. *"Bryant Park Alive with War Activities,"* New York Times, *June 16, 1918, sec. 3, p. 2, col. 2.*
2. *Kleemann 23, Griffith 2.*
3. *Henry James,* The American Scene *(1907; New York: Scribner's, 1946), p.77.*

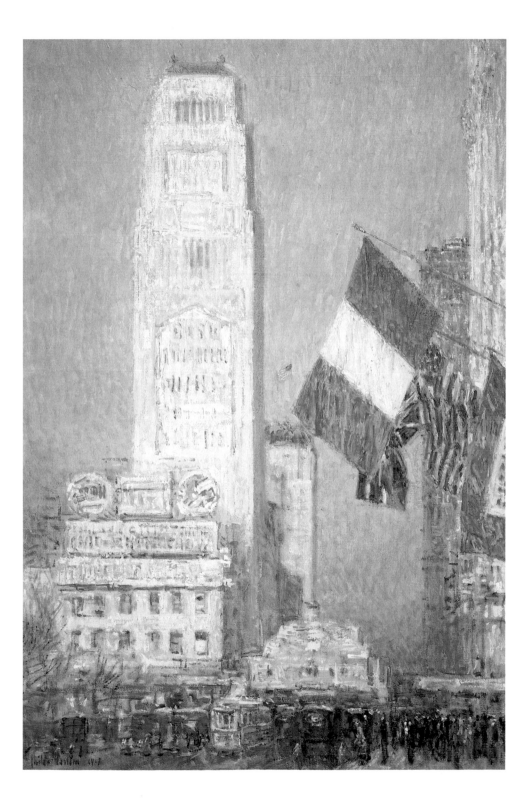

FLAGS ON FIFTY-SEVENTH STREET,
THE WINTER OF 1918
1918
Oil on canvas
36⅛ x 24 in. (91.7 x 60.9 cm.)
The New-York Historical Society,
New York
Bequest of Julia B. Engel, 1984

The intersection of Fifty-seventh Street and Sixth Avenue, as seen from Hassam's studio at 130 West Fifty-seventh Street, is shown in this painting. The two-story structure on the northwest corner contained the offices of Milch Brothers, a firm that began as a framing shop and later became a notable gallery for American art. Hassam showed his flag series there in the early summer of 1919. Although Fifty-seventh Street was a wide thoroughfare, it was not a popular locale for war-related activities. The large United States and service flags hanging from buildings on both sides of the streets probably were installed by the commercial businesses located there.

In addition to the uniqueness of its locale, this is the only painting in the flag series to depict a snow scene and is also distinctive in its use of perspective. Hassam modified his generally bright palette in accord with the weather and lighting conditions. Although he continued to work primarily with deep blues and white, the range of these colors is cooler, and the pigments are applied to a gray underpaint.

The sharp, bird's-eye view, derived from French impressionism and early photography, is suited to conveying the sense of buildings crowded together in a modern city. The street plane is tilted up by the high viewpoint, and movement into the scene is further prevented by placement of the elevated train station across the street. Unlike the other flag views, there is no sense of soaring buildings or deep space. Nor is there any of the ceremonial quality that characterizes so many of the later flag images. Instead Hassam's painting shows an ordinary winter day when few pedestrians have ventured out to brave the inclement weather.

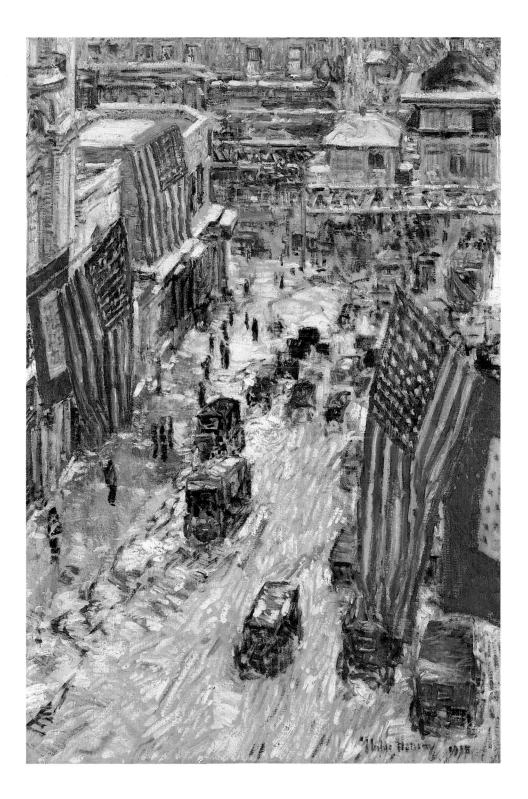

LINCOLN'S BIRTHDAY, 1918 (THE FLAG OF THE CITY OF NEW YORK ABOVE)
1918
Oil on canvas
36 x 24 in. (91.4 x 61 cm.)
Huntington Museum of Art,
West Virginia

On February 12, 1918, flags were displayed in celebration of Lincoln's birthday. Among the banners were the simple red and white flag of the Red Cross, the United States Navy jack with its white stars on a blue field, several national banners, and the City of New York flag that presides over this scene, flying high above the pavement. In 1915 New York adopted a new flag to commemorate the 250th anniversary of its first mayorship. The flag's blue, white, and orange colors were derived from those of the seventeenth-century banner of the United Netherlands. The emblem on the center white field was based on the corporate seal of New Netherlands and includes figures of an Indian, an English sailor, an eagle, a beaver, and a windmill. In Hassam's painting these details are not clearly indicated because of the effects of atmosphere, lighting, and breeze. The impressionistic handling of the buildings also hinders the identification of the specific locale.

The row of buildings with flags catches the sunlight directly. The light is so strong that the blue, white, and orange colors of the city's flag appear blue-green, white, and gold. Indeed the colors of the banners achieve a brilliance that is unusual even for Hassam's high-key flag images. The orange-yellows and blue-greens glow like neon lighting. The row of buildings on the opposite side of the avenue is in delicate blue and green shadows. As a background to the brilliantly colored banners, this soft, cool tonal effect enhances the brightness and clarity of the flags.

In the immediate foreground the thinly painted, swirling strokes of light blue paint over white suggest the wetness of the sidewalk and street. The sky is a brilliant white. Hassam had accurately recorded the weather conditions, for February 12 followed two days of snow and rain and was a mild winter day with temperatures in the mid-forties.

Mr. and Mrs. Arthur Dayton of Charleston, West Virginia, wanted to acquire the painting immediately after seeing it in a 1933 summer exhibition at M. Knoedler and Company. According to accounts kept by Mrs. Dayton, the dealer Robert Macbeth advised them that the artist "had a peculiar regard for this picture" and was reluctant to sell it.[1] The Daytons were finally able to purchase the painting directly from Hassam about a month before he died in 1935.

1. *Macbeth to Dayton, n.d., quoted in "Art Collection of Mr. and Mrs. Arthur Spencer Dayton," manuscript, p. 205, Archives, Huntington Museum of Art.*

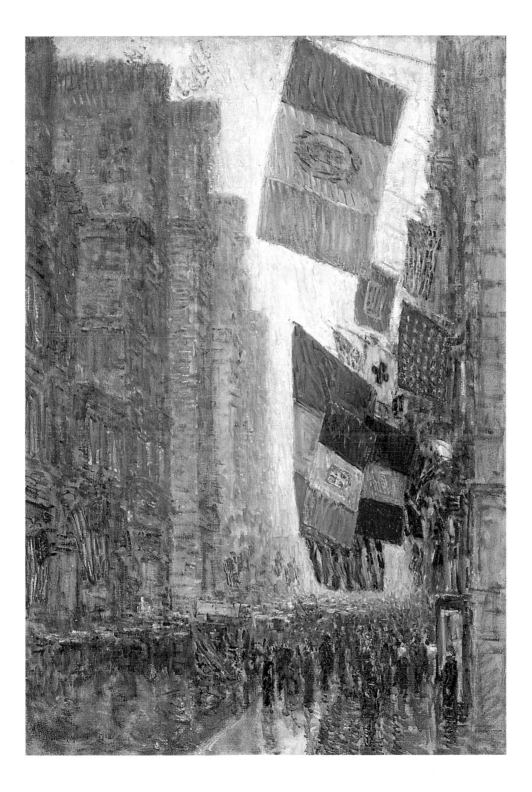

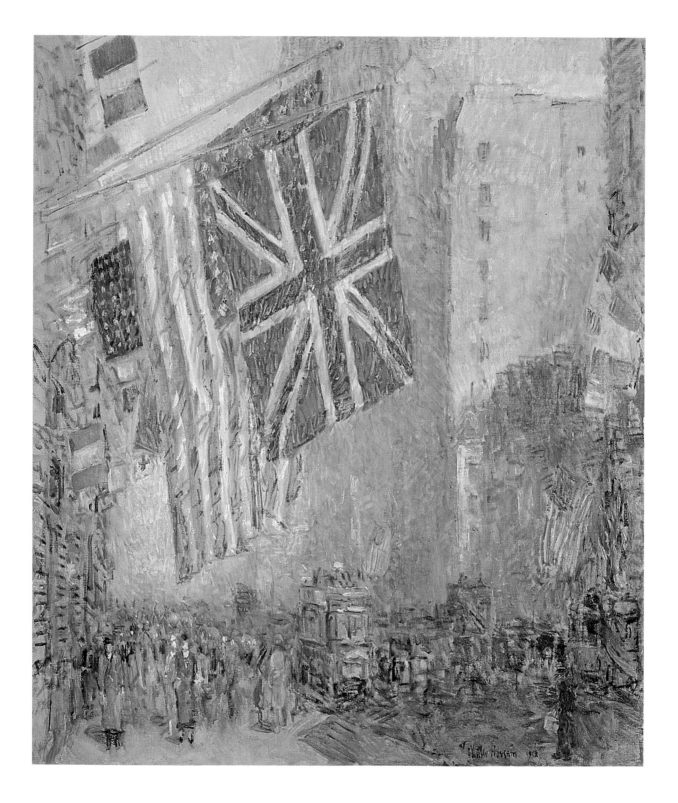

The anniversary of the United States entry into World War I is commemorated in this painting. Hassam's placement of Old Glory immediately behind the Union Jack symbolically suggests the aid America was giving Great Britain. The French tricolor also appears, but on a much smaller scale. About this time Hassam began to establish a specific type of composition in which the flag takes center place, thereby creating a strong geometric underpinning to the overall design and emphasizing the flag's symbolic role.

The importance of the flags was also asserted by the intensity of their hues and the thickness of the brushwork. The banners are the only objects with assertive colors. Everything else in the scene is in softer tints that contribute to the feeling of atmosphere and depth. Even the shadows are delicately colored, as would be dictated by the early hour. Hassam used his paint so sparingly that the sketchy strokes leave much of the underpaint visible. Only the flag of Great Britain reveals any significant degree of impasto. The artist later used this thin, sketchy handling, with its overall light tonality, to convey the delicate lighting of late afternoon in *Avenue of the Allies: Brazil, Belgium, 1918,* 1918 (pl. 24).

THE UNION JACK,
APRIL MORNING, 1918
1918
Oil on canvas
34 x 30 in. (86.4 x 76.2 cm.)
Hirshhorn Museum and Sculpture
Garden, Smithsonian Institution,
Washington, D.C.
Gift of Joseph H. Hirshhorn, 1966

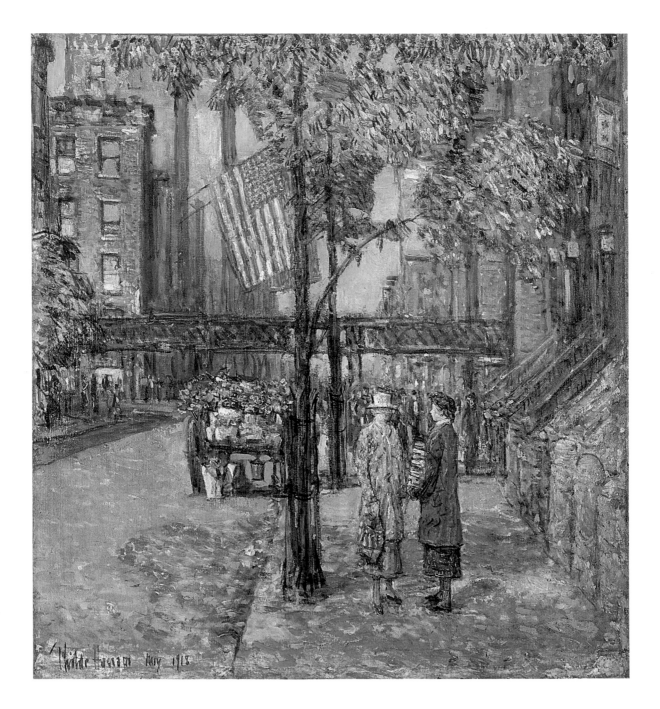

Established in 1904, the Friar's Club is a private men's organization whose members are the elite of the entertainment industry. In the autumn of 1916 it opened a seven-story clubhouse, designed by Harry Allan Jacobs, on the south side of West Forty-eighth Street between Sixth and Seventh avenues. It was an impressive building whose Tudor-Gothic facade and high mansard roof towered above the neighboring houses.

Hassam chose not to focus on the Friar's Club and almost completely obscured its distinguished facade by using an extremely oblique viewpoint. Standing a block away from the building, the artist presented a distant view of the ordinary side street with its brownstones and the Sixth Avenue elevated train line cutting across the scene. Only the large flags in the middle distance indicate the clubhouse.

This scene is very similar to the charming images of New York pedestrians that Hassam had painted much earlier. The emphasis is on the daily activity in the street—the two women who stop to chat and the flower vendor—which is much slower paced than the hectic bustle of Fifth Avenue. The tracks of the elevated train are unobtrusive and barely hint at the modern life-style of which the train system was an essential part. Nor is a single automobile included. It is almost as if Hassam delineated a different world. The clear blue sky and the trees in their sparkling green and yellow spring foliage all contribute to the work's picturesque quality. The war intrudes only slightly through the presence of the large United States flags and a small service flag in the upper-right foreground.

By the spring of 1918 Hassam had already evolved a type of flag imagery that symbolized the modern-day power of the Allies to be victorious. It is probably because this painting does not fit such celebratory iconography that the artist never exhibited it as part of the series.

FLAGS ON THE FRIAR'S CLUB
1918
Oil on canvas
26 x 24 in. (66 x 61 cm.)
Mead Art Museum, Amherst College, Massachusetts
Gift of Henry Steele Commager

RED CROSS DRIVE, MAY 1918
Also known as
CELEBRATION DAY
1918
Oil on canvas
35½ x 23½ in. (90 x 59.7 cm.)
The Eleanor and C. Thomas May Trust
for Christopher, Sterling, Meredith
and Laura May

Inspired by what must have been a stirring tribute on behalf of the international humanitarian organization, Hassam created one of his most monumental flag paintings. On May 18, 1918, parades were held in New York and elsewhere to celebrate the activities of the Red Cross. The official parade was held on Fifth Avenue from Eightieth Street to Washington Square. Two days later a week-long drive for the organization's second war fund began, and images of the Red Cross appeared throughout the city on large banners and in electrical illuminations.

The Red Cross has a simple banner, consisting of a large red Greek cross on a white field. Hassam transformed it into a symbol of great majesty and presence by viewing the scene directly from the center of Fifth Avenue, so that the row of Red Cross flags is centrally placed and seen against a silvery white sky. By standing fairly close to the ground and looking upward, Hassam produced the illusion of flags enormous in size compared with the pedestrians and street traffic. The banners of various Allied nations hang with other Red Cross flags from the buildings all along the avenue. In this international display of cooperation and goodwill, the different colors and designs of the banners greatly enliven an already stirring scene.

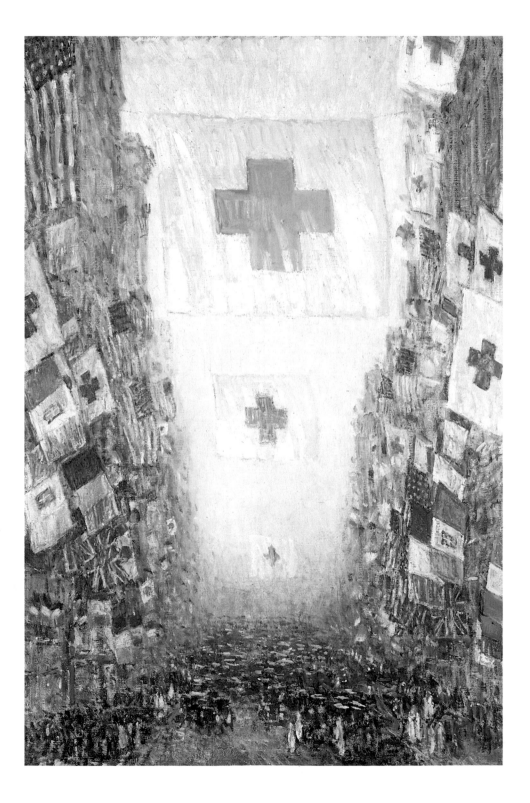

ITALIAN DAY, MAY 1918
Also known as
THE ITALIAN BLOCK
1918
Oil on canvas
36 x 26 in. (91.4 x 66 cm.)
Collection of the American Academy
and Institute of Arts and Letters,
New York

Italy-America Day was held on May 24, 1918, and commemorated the third anniversary of Italy's entry into the war against its former allies, the Central Powers. Because the celebration coincided with the week-long drive to raise money for the Red Cross, Hassam's scene features as many Red Cross banners as Italian flags. The inclusion of one large American flag next to a similarly scaled Italian banner symbolizes the alliance between the two countries.

This is Hassam's only flag painting that includes an airplane. Aviation did not realize its potential until World War I led to its development for military uses. On May 15, 1918, a biplane had transported the United States mail by air for the first time. Airplanes were also employed during the Liberty Loan Drives to facilitate the dispersal of promotional literature over large geographical areas, and aeronautical displays were held as a part of fund-raising activities. During the Second Liberty Loan Drive, in the autumn of 1917, a captain from the Italian army, Emilio Resnati, startled New York by circling over the Woolworth Building to advertise the drive. A newspaper photograph of the event (fig. 60) shares with Hassam's painting a low perspective, emphasizing the soaring height of the buildings and the small size of the biplane, as well as the placement of the plane near the top edge of the composition. The painting may be a memorial to Resnati, who died in an aeronautics accident only a few days before Italy-America Day.

Unlike the photographer, Hassam did not focus on the buildings or the airplane. He left the distant view open so that the eye is forced back to the right foreground, which is crowded with flags. These take precedence through their placement in the foreground, their size, and the brilliance of their hues. The red, white, and green of the Italian flag establishes the palette of the scene. This is the only flag painting in which the dominant color is a rich green. Greens appear not only in the flags but also as an opalescent hue in the distant buildings and as softer hues in the reflection of the flags on the wet pavement. The festive air established by the flags prevails, despite the recent shower indicated by the wet street and slightly clearing sky.

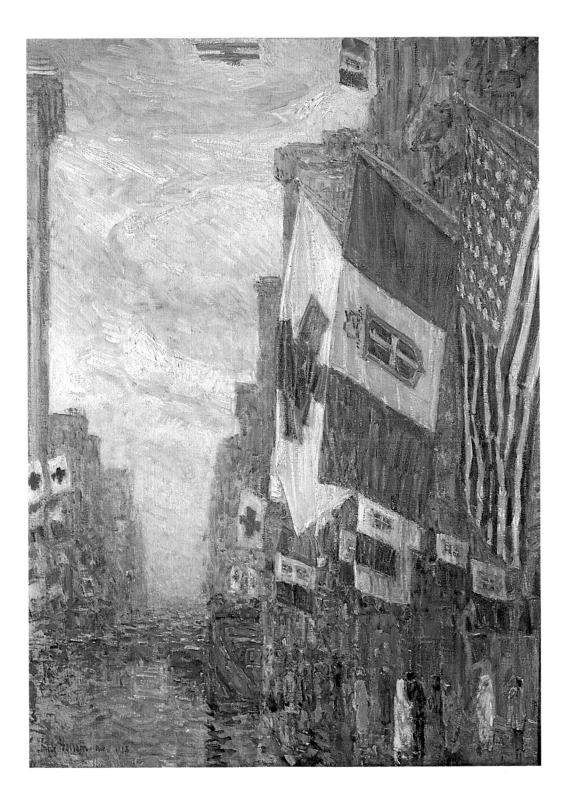

*Across the Avenue in Sunlight,
June 1918*
1918
Oil on canvas
26 x 36 in. (66 x 91.4 cm.)
IBM Corporation, Armonk,
New York

In this painting three large flags representing the major Allies decorate the entrance of M. Knoedler and Company, whose art gallery occupied this large multistory building on Fifth Avenue near Forty-sixth Street from 1911 to 1925. During the war the dignified Beaux-Arts structure, originally designed by McKim, Mead and White for the Lotus Club, was often decorated with flags and other patriotic bunting (fig. 11). In Hassam's painting a service flag is partially seen above the entrance, but it is the three huge American, British, and French flags that dominate the scene. As one early commentator noted, these banners seem to be "floating above the head[s] of passersby as though promising protection and a shield from danger."[1]

This canvas has the distinction of being one of the few horizontal flag paintings. As with *Allied Flags, April 1917,* 1917 (pl. 7), Hassam depicted a well-known building and focused on it almost to the total exclusion of other structures. Unlike the completely frontal view he used for *Allied Flags, April 1917,* for this scene the artist was forced to stand on a slight diagonal in order to see the flags more fully because they hung from poles jutting out over the street rather than being displayed flat against the building like the banners on the Union League Club.

The sunlight appears to have a stronger effect here than in any of the other flag paintings. It is midmorning in early summer, and the intense light affects the highlights as well as the shadows. As in the flags and pavement, traces of yellow added to different colors give a brighter, sunnier feeling to the building. Cobalt blue and dark purple, colors complementary to the yellows and oranges, appear as shadows. The stone facade flashes with bits of yellow, gold, and orange as well as turquoise, green, and blue. Contributing to the sumptuous effect is Hassam's handling. He energetically applied a full brush of paint, so that the entire surface has a good degree of impasto. As in most of the flag paintings, the banners were accorded the richest treatment.

1. *"Painting America: Childe Hassam's Way,"* p. 279.

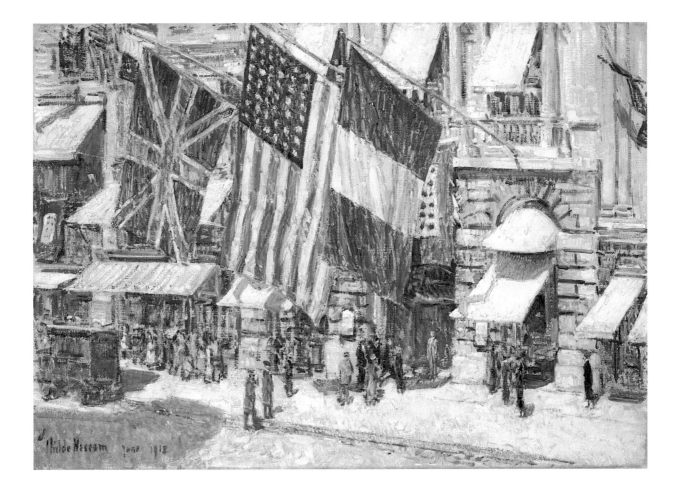

AVENUE OF THE ALLIES: FRANCE, 1918
(THE CZECHO-SLOVAK FLAG IN THE
FOREGROUND, GREECE BEYOND)
1918
Oil on canvas
37 x 26 in. (94 x 66 cm.)
Musée National de la Coopération
Franco-Américaine, Blérancourt,
France

During the Fourth Liberty Loan Drive the decoration of each Fifth Avenue block in mid-Manhattan was devoted to one of the Allies (fig. 22). For this painting Hassam stood near the intersection of Forty-seventh Street and Fifth Avenue, looking south. The block from Forty-eighth to Forty-seventh streets was allocated to Czecho-Slovakia, and the flag of that provisional nation hangs conspicuously in the foreground opposite Old Glory. The block from Forty-seventh to Forty-sixth streets was devoted to France, and it is the red, white, and blue of the French tricolor that most often appears in this scene, hanging in rows from buildings and suspended across the thoroughfare. Looking toward Forty-fifth Street, one can see a large version of the pastel blue and white striped flag of Greece hanging in the distance.

The white service flag with red border and stars, which appeared in increasing numbers as the war progressed, hangs in the upper-right corner. During this loan drive scarlet banners were scattered throughout the displays. Some, with the name of an individual ally on them, were strung across the ends of the block honoring a specific country. Other brilliant red banners were inscribed, "Buy Liberty Bonds!" In terms of the number of flags, this is the most congested of Hassam's five paintings devoted to the Fourth Liberty Loan Drive. There are so many banners that the buildings are barely visible, and only a bit of sky is indicated. Hassam's scene accurately represents the "fluttering, panoplied way" of what was then being called the Avenue of the Allies.[1] The inscription on the painting appears to be "Oct. 11, 1918," which was Montenegro Day.

The flags dominate; everything else is secondary. A clear blue sky delicately illuminates the higher banners. Pedestrians and vehicles are sketchily indicated by a series of strokes and color dabs, intended to provide only an impression, and it is difficult to recognize the double-decker bus in the foreground. The colors of the flags—ultramarine, white, and coral red—establish the scene's festive mood.

By the time of Hassam's death this painting fittingly was in the collection of the Musée du Louvre.[2] As a critic said at the time of the first exhibition of the series at Durand-Ruel: "There are plenty of persons in this country who have an overwhelming sense of the importance of the relation of our country to the French Republic. If some of these got together and presented to the Luxembourg one of the canvases in which...Hassam has expressed the spirit of America in the war it would be well for us as a city and well for coming generations of our illustrious ally."[3]

1. *"'Avenue of the Allies' Waves Its Message in Glow of Color,"* New York Tribune, *September 29, 1918, p. 9, col. 6.*
2. *The records of the Musée du Louvre reveal neither the exact date of acquisition nor whether the painting was a government purchase or gift.*
3. *"Childe Hassam Expresses New York's Spirit in Avenue of the Allies," p. 3, col. 3.*

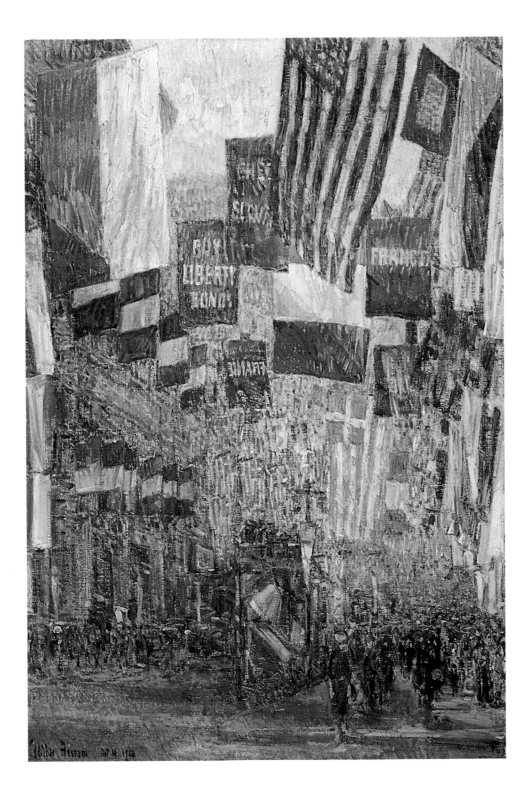

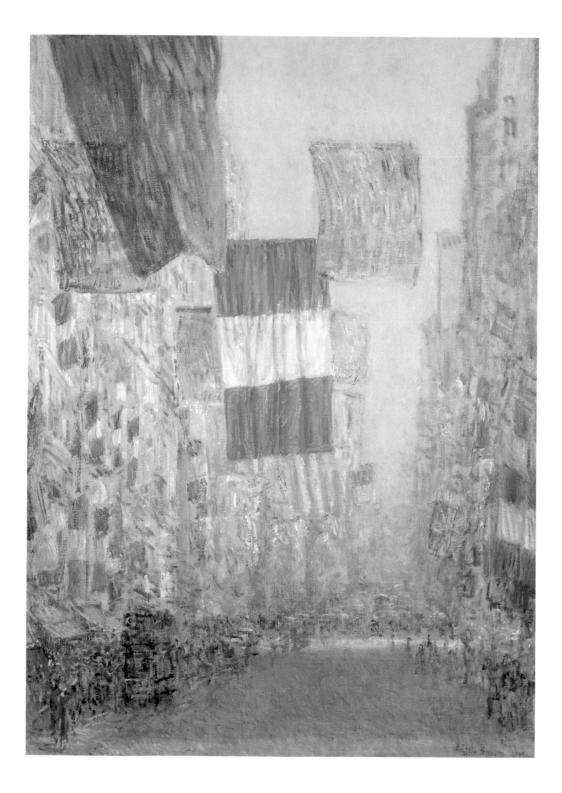

For this painting Hassam looked up Fifth Avenue from just below Forty-fourth Street. The focus is on the block from Forty-fourth to Forty-fifth streets, which was devoted to Guatemala during the Fourth Liberty Loan Drive. That country's flag with light blue and white vertical fields is placed exactly in the center of the composition and displayed in its entirety. The flag is relatively motionless despite the breeze that moves other banners. Numerous smaller Guatemalan national banners decorate the buildings along both sides of the street. The simple, blue and red flag of Haiti flutters in the upper-left corner and brings the viewer into the scene. It was during this loan drive that the street became known as the Avenue of the Allies because the flags of all the Allies, including small nations such as Guatemala and Haiti, were featured with equal prominence. Several large, bright red banners associated with the overall scheme of the loan-drive decorations hang throughout the scene.

Here Hassam used a thinner paint than usual. Even for the banners—sometimes the only objects in his flag scenes to have impastoed surfaces—the artist did not apply the pigment thickly. In fact, in large areas such as the Haitian flag the paint is so thin that the banner in back can be seen through it. Although the large flags are sharply delineated, the view as a whole is delicately painted, and the overall impression is more amorphous than the other Fourth Liberty Loan images.

AVENUE OF THE ALLIES, 1918 (HAITI, GUATEMALA; GREECE, FRANCE BEYOND)
1918
Oil on canvas
36 x 26 in. (91.4 x 66 cm.)
Private collection

AVENUE OF THE ALLIES, 1918 (ALLIED FLAGS IN FRONT OF SAINT PATRICK'S CATHEDRAL, SERVICE FLAG ON UNION CLUB, CHINA, GREAT BRITAIN, BELGIUM BEYOND)
1918
Oil on canvas
36 x 28 in. (91.4 x 71.1 cm.)
Private collection

During the Fourth Liberty Loan Drive the block of Fifth Avenue on which Saint Patrick's Cathedral is located (the east side of Fiftieth to Fifty-first streets) was designated the site of a special Liberty Loan display. Twenty-two tall poles, each carrying the flag of an Allied country, were installed in front of the cathedral, while above flew the flags of the United States and the Liberty Loan Drive. Although a writer called it "a sonorous climax" to the pageant,[1] Hassam did not emphasize this unique display, preferring to indicate only a few of the flagpoles as seen from an extreme side view. He probably decided that the inclusion of more flagpoles would only have confused an already crowded scene.

Unlike the other Fourth Liberty Loan flag paintings, which offer a vista up or down Fifth Avenue, in this scene Hassam moved farther onto the pavement to view the street obliquely. He even limited his depiction of Saint Patrick's, one of his favorite structures, to the south corner of the Gothic-revival church. Consequently the street before Saint Patrick's appears to be a wide square framed by the cathedral and the sunlit buildings in the background.

Hassam controlled and organized his strokes, so that in its handling this painting has the least impressionistic brushwork of all the Fourth Liberty Loan paintings. Even the pedestrians are clearly delineated, not mere strokes of a single color, as in most of the other paintings, but large, distinguishable figures dressed in the latest attire.

Saint Thomas's Episcopal Church and the tall Gotham Hotel building beyond catch the brilliant rays of sunlight, which transform the white masonry into a magnificent backdrop of opalescent hues. Because the entire scene is infused with this light, the deeper colors are richer and the shadows bluer. Hassam used the sunlight to clarify shapes and forms rather than to disintegrate them. He was also aware of how weather conditions can create a mood. With flags gently moving in the wind and a clear, sunny morning light, this scene seems to sing joyously of freedom and liberty.

1. *"'Avenue of the Allies' Waves Its Message in Glow of Color,"* New York Tribune, *September 29, 1918, p. 9, col. 6.*

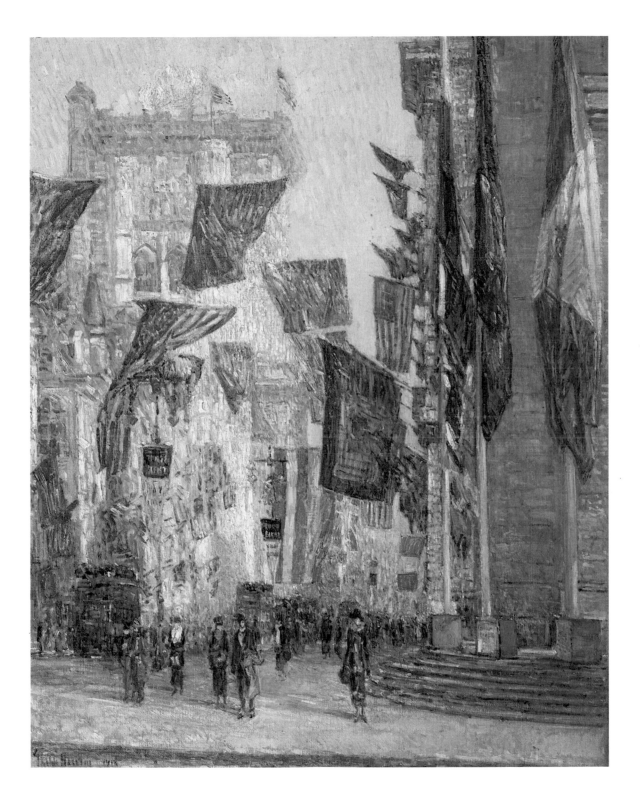

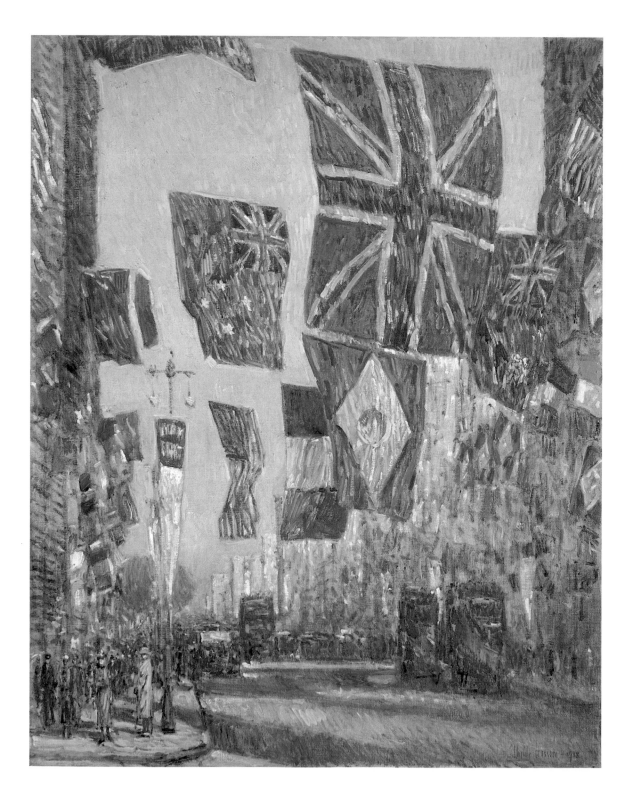

During the Fourth Liberty Loan Drive the flags of the British Empire (Great Britain and its dominions) were displayed in all their splendor along the block of Fifth Avenue from Fifty-third to Fifty-fourth streets. Hassam stood looking at the northwest corner of Fifty-third Street, with a view up the avenue to the beginning of the flag decorations at Fifty-eighth Street, where the large Stars and Stripes hanging in the distance was part of a special Liberty Loan and United States display. The large Union Jack flying high above brings the viewer into the scene. Behind it to the left is the merchant flag of New Zealand, with its pattern of four stars on a red field, and to the right the merchant flag of Canada. The flags of Brazil and then Belgium fly beyond in the next blocks.

It is a sunny morning on a crisp, breezy autumn day. The hour, weather, and season are indicated by the long shadows that crisscross the avenue, the clear turquoise blue sky, and the gentle movement of the flags. The entire scene evinces strong, full-bodied hues. The reds and blues of the British flags establish the dominant color chords. The addition of strokes of yellow and white in the large flags creates a sense of brightness and glare. Even the distant street traffic is painted in a more intense blue than Hassam usually employed in the backgrounds of his flag paintings. Because the double-decker buses are in shadow their green and yellow colors have been transformed to blue overall with green staircases.

This painting is a stunning example of the power of Hassam's design sensibility. The large flags set against the light sky form a strong pattern of vibrant colors and rhythms. The artist manipulated the scene to emphasize specific flags. Although he included a considerable number, Hassam omitted many in order to avoid the congestion that characterizes *Avenue of the Allies: France, 1918,* 1918 (pl. 20). Furthermore he carefully plotted the placement and scale of the flags, choosing a vantage point from which the Union Jack would be the central and largest object seen. Set against the light blue sky in the immediate foreground, it dominates the scene, just as Great Britain controlled its empire.

AVENUE OF THE ALLIES:
GREAT BRITAIN, 1918 (THE FLAGS OF
THE COLONIES: CANADA AND ANZAC;
BRAZIL AND BELGIUM BEYOND)
1918
Oil on canvas
36 x 28⅜ in. (91.4 x 72.1 cm.)
The Metropolitan Museum of Art,
New York
Bequest of Miss Adelaide Milton
de Groot, 1967

AVENUE OF THE ALLIES: BRAZIL,
BELGIUM, 1918
Also known as
FLAG DAY
1918
Oil on canvas
36⁵⁄₁₆ x 24⁵⁄₁₆ in. (92.1 x 61.8 cm.)
Los Angeles County Museum of Art
Mr. and Mrs. William Preston
Harrison Collection

According to its inscription, this view was painted on October 19, the last day of the Fourth Liberty Loan Drive, which was devoted to the United States. The location is almost the same as in *Avenue of the Allies: Great Britain, 1918,* 1918 (pl. 23), except that Hassam moved slightly north to concentrate more on the block between Fifty-fourth and Fifty-fifth streets, which was devoted to Brazil. He also moved from the west to the east side of the avenue and to a more elevated position. In both paintings he excluded the myriad scarlet Liberty Loan banners scattered throughout the displays to concentrate on the emblems of the Allies. The flag of New Zealand is large and placed directly in the foreground, high above the viewer. However, it is the next two banners suspended over the avenue—those of Brazil and Belgium—that are meant to be the narrative focus. The Brazilian flag—a yellow diamond on a bright green field with a blue globe in the center—appears as the large, centrally placed banner suspended over the street and in groups flying from staffs on the buildings to right and left. The block north was devoted to Belgium, whose simple black (here shown as blue), yellow, and red flag flies directly behind Brazil's. The plight of Belgium held a special place in the public imagination from the very beginning of World War I when the Germans violated its neutrality.

Although they represent almost the same locale, this painting and *Avenue of the Allies: Great Britain, 1918* differ sharply in appearance. The soft, more delicate hues of *Avenue of the Allies: Brazil, Belgium, 1918* are unlike the intense coloration of the other canvas, which depicts brilliant morning sunlight. Here Hassam viewed the street at four in the afternoon and chose to depict the cooler atmosphere, an almost white sky, more typical of the end of an autumn day.[1] He achieved this not only by lightening his palette and extensively using colors in a lower key but also by using paint more sparingly and leaving a great deal of canvas exposed.

One of the earliest Hassam flag paintings to be purchased, this canvas was bought by William Preston Harrison of Los Angeles in 1925. Four years later he donated it to the Los Angeles Museum of History, Science and Art. It thus became one of the first flag paintings to enter a public collection. The work is well known through the related lithograph, which differs only slightly in the details of a few of the foreground figures. The print served as the frontispiece of Albert E. Gallatin's book *Art and the Great War* (1919).

1. *The time of day, four in the afternoon, is part of the inscription on the related lithograph,* Avenue of the Allies, 1918 *(Kleemann 2, Griffith 43). The subject of the print has been mistakenly linked to the painting* Avenue of the Allies, 1918, *1918 (pl. 22).*

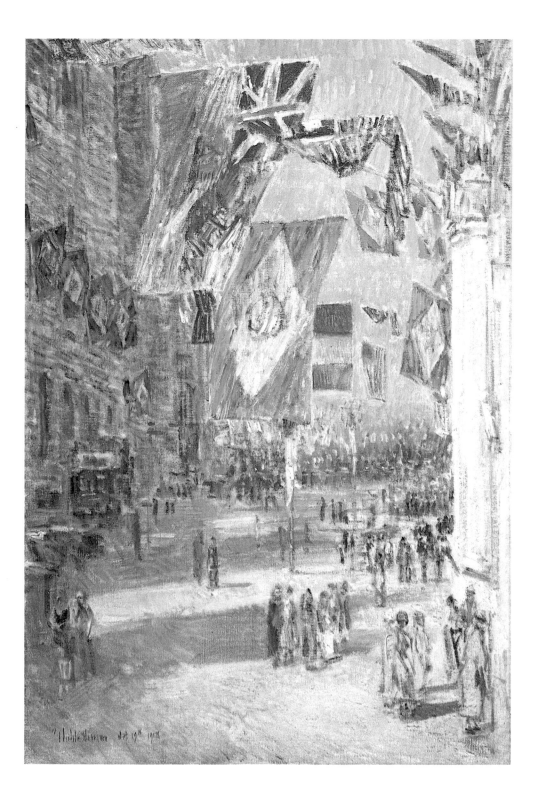

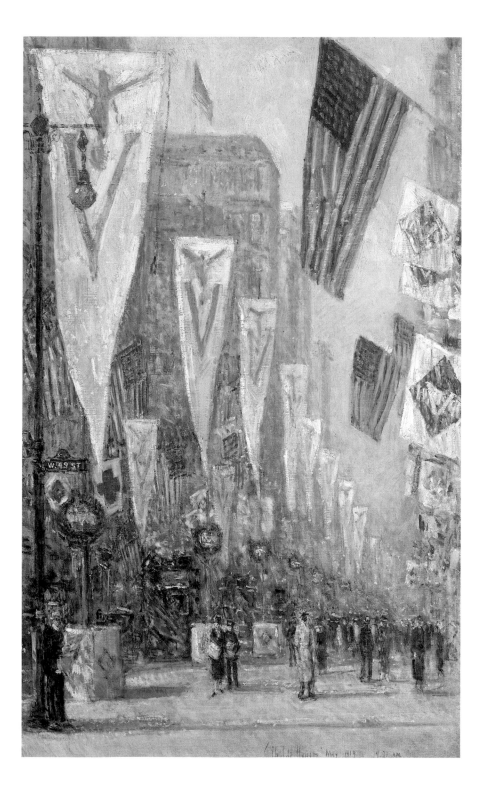

The last painting in the flag series, this canvas was created after the war ended. Large blue and white victory pennants and red and white victory banners dominate the flag display, although the Stars and Stripes is still prominent. As in Hassam's other views of Fifth Avenue, the pedestrians appear small beneath the towering skyscrapers and banners.

The painting is inscribed "May 1919—9:30 A.M." First exhibited as part of the flag series in the Milch Galleries showing that opened on May 20, 1919, it had to have been completed before that date. It probably was done during the beginning of the month, possibly even on May 6 when New York welcomed home its Seventy-seventh Division with a review and parade. In this scene Fifth Avenue takes on an especially festive air with victory banners and garland-framed signs placed all along the thoroughfare. Because of the early hour Hassam recorded the crowds before any of the street celebrations actually began. His specificity concerning the time of day implies that the omission of the exact date was intentional. Perhaps he meant this image to symbolize all victories of liberty and democracy over inequity and tyranny rather than a specific celebration.

The early morning hour may also account for the overall cool, somewhat misty quality of the scene. Pastel blue and white have allusions to spirituality and purity, and it is these colors of the large victory pennants that establish the mood. Indeed an overwhelming sense of serenity, a newfound peace, pervades the scene.

VICTORY WON
Also known as
VICTORY DAY
1919
Oil on canvas
36 x 22 in. (91.4 x 55.9 cm.)
Collection of the American Academy and Institute of Arts and Letters, New York

Childe Hassam's flag paintings—those in the official series as well as related street scenes—appear at first to be a homogenous group of impressionist views of New York decorated with flags. Indeed Hassam conceived of the flag images as impressionist paintings. They became his most important mature works in this aesthetic, and contemporaries considered them to be exemplary impressionist paintings, referring to them as his "most daring effort" and "the supreme glory of [his] career."[1] However, the flag paintings are much more than pure impressionist images. They changed over the course of the three years Hassam worked on them and consequently exhibit a greater variety and complexity than are first apparent. The changes, rather than constituting a single, linear development, reveal Hassam's subtle move away from the ideals of orthodox impressionism toward a postimpressionist aesthetic. The paintings became different as the artist emphasized clarity and structure by increasingly controlling his brushwork and manipulating the compositions.

The evolution of the flag series was further determined by the iconography of the paintings. The themes of national banners and the modern city emerged as the major motifs. Hassam's repetition of the image of Old Glory in the early paintings underscored the intensified spirit of patriotism that Americans experienced during World War I. As he added other national banners, the paintings took on more of an international overtone. Yet the United States flag retained its special role and in fact assumed new meaning in the context of its urban setting. The image of the city was an essential element of Hassam's art throughout his career. By the time of the flag paintings New York had become the most modern and technologically advanced city in America, representing the progress of the country as a whole. Hassam's flag paintings reflected the nation's patriotic spirit as well as pride in its modern power. The paintings themselves became symbols of America's new position in the international arena.

Hassam received his first extensive exposure to French impressionism when he lived in Paris from late 1886 to the summer of 1889. Impressionism came late to the United States—the first substantial exhibition was held at the New York galleries of Durand-Ruel in 1886—and was not well understood for many years. The theoretical tenets of French impressionism as first espoused in the 1860s and early 1870s emphasized light, atmosphere, and weather conditions. The impressionists studied the interaction of light and color on objects and strove to capture in their paintings the impressions of transitory nature. Even before his Paris visit Hassam shared with the impressionists many common interests, as evidenced by his city views of Boston in which he had painted scenes of contemporary life and explored variations in natural lighting and weather conditions. The most notable change in Hassam's work of the 1890s, resulting from his Parisian experience, was his adoption of a heightened palette and a looser, broken brushwork. These formal characteristics were essential to impressionist painting.

Hassam created his earliest flag paintings in France. The first were of flags

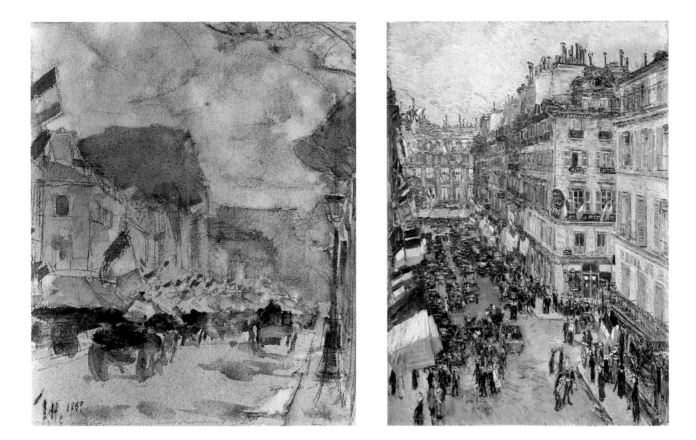

flying in the artists' section of Paris on Bastille Day: the watercolors *Fourteenth July, Paris, Old Quarter,* 1887–89 (Museum of Art, Carnegie Institute, Pittsburgh), and *July Fourteenth, Montmartre, Paris,* 1889 (fig. 33), and a small oil painting, *La Butte, Montmartre, July Fourteenth,* 1889 (private collection). In *July Fourteenth, Montmartre, Paris* Hassam presented the celebration as a deep vista, with a parade of carriages carrying French tricolor flags away into the distance. On his last trip to France, in the summer of 1910, he returned to the theme, creating the oil painting *July Fourteenth, Rue Daunou* (fig. 34). Inspired by the colorful national celebrations, Hassam's specific interpretations were informed by his knowledge of French art.

The iconography of a city decorated with flags had French antecedents. During the *Fête de la Paix* on June 30, 1878, the flag of France's Third Republic was displayed throughout Paris. This celebration was the first French national holiday since 1871 during which the streets of the capital were decorated. After the Franco-Prussian War and the collapse of the Second Empire, the new republican regime banned large gatherings to prevent antigovernment demonstrations. The 1878 festivities signified that the government of the Third Republic was stable and that the country was again on the road to material and cultural

Fig. 33
Childe Hassam
JULY FOURTEENTH, MONTMARTRE, PARIS, 1889
Watercolor on paper
7¾ x 6¼ in. (19.7 x 15.9 cm.)
Collection of Hirschl & Adler Galleries,
New York

Fig. 34
Childe Hassam
JULY FOURTEENTH, RUE DAUNOU, 1910
Oil on canvas
29 x 19⅞ in. (73.7 x 50.5 cm.)
The Metropolitan Museum of Art,
New York
George A. Hearn Fund, 1929

Fig. 35

Édouard Manet (France, 1832–1883)
*The Rue Mosnier, Paris, Decorated
with Flags,* 1878
Oil on canvas
25½ x 31½ in. (64.8 x 80 cm.)
Collection of Mr. and Mrs. Paul Mellon,
Upperville, Virginia

progress. The celebrations were on a grand scale during which, according to newspaper accounts and illustrations, buildings disappeared under a flurry of banners. Édouard Manet and Claude Monet painted the spectacle of flags: Manet did two views, both titled *The Rue Mosnier, Paris, Decorated with Flags,* 1878 (fig. 35), from his studio window at 4 rue Saint-Petersbourg, while Monet chose a more elegant and crowded area of Paris for two images, *Rue Saint-Denis* (Musée des Beaux-Arts et de la Céramique, Rouen) and *The Rue Montorgueil, Festival of June 30, 1878,* 1878 (fig. 36). In 1906 another French artist, Raoul Dufy, would give flag imagery an even bolder, fauve slant in his series of the rue Pavoisée in Le Havre (fig. 48).

In *July Fourteenth, Rue Daunou* Hassam, like Monet in *Rue Montorgueil,* depicted Paris during a national holiday when French flags were hanging from all stories of many buildings. Hassam might have had the opportunity to see Monet's painting in Paris when it was exhibited at the Galerie Georges Petit during the early summer of 1889, but it was his general familiarity with Monet and the art of other impressionists that definitely contributed to the similarities between the two flag paintings.[2] Monet and Hassam shared a fascination with city life and chose to depict Paris from on high, using balconies for their vantage points.[3] During the 1860s and 1870s this elevated perspective was popularized in city views by French impressionists and early photographers. Camille Pissarro was the impressionist who perhaps used it most often, especially in the 1890s, when he captured the streets of Paris crowded with pedestrians (fig. 37). Beginning in the 1890s Hassam occasionally used a similar high perspective, and it became a major element of his World War I flag paintings.

Hassam's *July Fourteenth, Rue Daunou* differs drastically from Monet's *Rue Montorgueil* in terms of brushwork and mood. Monet's image conveys the extraordinary intensity of the enthusiastic patriotic celebration. The countless flags burst with energy as they slash through the air, their diagonal placement forming a crescendo. The street below is teeming with figures, indicated by long dabs of paint that fill the pictorial area left open by the flags. Hassam's painting conveys little of this enthusiasm; the flags are fewer in number and hang quietly from the buildings as pedestrians go about their normal activities on a quiet thoroughfare. Compared with the spontaneity of Monet's handling, Hassam's is much more controlled and regular. The overall cool tonality of Hassam's palette differs from the vigorous coloration of Monet's flags. Hassam's painting shares the quieter mood of Manet's interpretation of the rue Mosnier. Much of Hassam's art of the 1910s exhibits a controlled, methodical handling, despite thick strokes, and this may account for the restraint in *July Fourteenth, Rue Daunou.* However, the lack of enthusiasm may just as easily be explained as the reaction of an outsider observing the celebration of another country's national holiday.

When Hassam returned to the flag theme in 1916, his initial interpretation, *Just off the Avenue, Fifty-third Street, May 1916* (pl. 1), was almost an ordi-

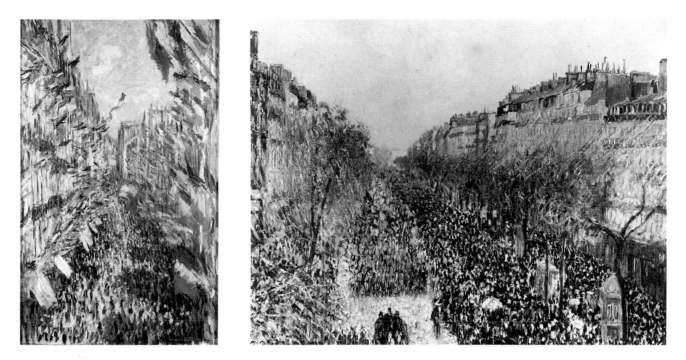

nary street scene on a sunny spring day. In mood and handling it is close to the sun-filled depictions of country life that he had painted during peacetime, for example, *Stone Cottage at Old Lyme,* 1903–15 (Mint Museum of Art, Charlotte, North Carolina). Hassam soon turned away from such sedate interpretations. Perhaps the artist's excitement over the flag imagery grew as the war spirit intensified and as he encountered more banners on the streets. *The Fourth of July, 1916 (the Greatest Display of the American Flag Ever Seen in New York, Climax of the Preparedness Parade in May),* 1916 (pl. 2), *The Avenue in the Rain, 1917,* 1917 (pl. 5), and *Afternoon on the Avenue, 1917,* 1917 (pl. 6), display an enthusiasm in the brushwork and a charged mood that were extreme for him.

The French impressionists painted with broken, sketchy strokes of different sizes and with softened contours, preferring to create the impression of the effects of light, air, and movement on a scene rather than to describe its physical details. In general American artists, Hassam included, tended to be less impressionistic than the French. The Americans retained a greater sense of finish and solidity of form, rarely portraying objects as disintegrating under the influence of light and color. Hassam's brushwork changed over the years, and about the turn of the century it was closest to the French manner of handling. By the 1910s his brushwork was often controlled and regular, even though still impressionistic. In the flag paintings from 1916 and 1917 at times it is looser, expressive, even energized. The long, bold strokes of red and white pigment in the flags of *The Fourth of July, 1916* assert a new strength, expressive of the new determination of the American spirit. In *Afternoon on the Avenue, 1917* Hassam's

Fig. 36
Claude Monet (France, 1840–1926)
THE RUE MONTORGUEIL, FESTIVAL OF JUNE 30, 1878, 1878
Oil on canvas
31½ x 19⅛ in. (80 x 48.5 cm.)
Musée d'Orsay, Paris

Fig. 37
Camille Pissarro (France, 1831–1903)
BOULEVARD MONTMARTRE, MARDI GRAS, 1897
Oil on canvas
26 x 31½ in. (63.5 x 80 cm.)
The Armand Hammer Collection

Fig. 38
Childe Hassam
THE SERVICE FLAG, 1918
Lithograph
9 x 6 in. (22.9 x 15.2 cm.)
The Baltimore Museum of Art
Gift of Mrs. Childe Hassam

brushwork is softer; the buildings with flags appear to be an image only faintly seen. The handling is more irregular and quicker in *The Avenue in the Rain, 1917,* varying from the crusty impasto on the flags to the soft, almost rubbed areas of paint for the distant buildings and reflections; the flags seem to shimmer as if in a vision. Even as Hassam's expressiveness came closer to Monet's energetic brushwork in *Rue Montorgueil,* he retained some element of control, as seen in the regular, orderly vertical strokes of the sky in *Afternoon on the Avenue, 1917.*

At the core of much impressionist painting was a fascination with transitory effects of nature and the way color and light could convey the impression of seasons of the year, weather conditions, and different times of day. In the later flag paintings Hassam became more concerned with the symbolic value of the flags, and although he grew less interested in a faithful depiction of nature, the artist never fully relinquished impressionist concerns. In some of the paintings he demonstrated an impressionist obsession for capturing the fugitive quality of nature by using descriptive titles and adding inscriptions to his signature that provide specific information about the month, weather conditions, or hour of the day.

The season Hassam painted can be ascertained for most of the images. Many of the later ones were inspired by specific celebrations, for example, *Red Cross Drive, May 1918,* 1918 (pl. 17), which depicts festivities held the week of May 18, 1918. The seasons can also be determined by Hassam's naturalistic use of color, light, and brushwork. He created twelve flag paintings during spring—a popular season with the French impressionists—when the sky is a clear cerulean color. This was a greater number than he painted in any other season, and all were done in the months of April and May. In many cases, such as *Allies Day, May 1917,* 1917 (pl. 8), and *The Union Jack, April Morning, 1918,* 1918 (pl. 15), the flags are clearly poised against a cloudless sky. Occasionally the artist added cumulus clouds, but they always appear in what is otherwise a clear spring sky, as in *Italian Day, May 1918,* 1918 (pl. 18). A gusty spring wind blows the flags about in *Early Morning on the Avenue in May 1917,* 1917 (pl. 11).

Only two flag paintings can be associated with summer: *The Fourth of July, 1916* and *Across the Avenue in Sunlight, June 1918,* 1918 (pl. 19). *The Fourth of July, 1916* could easily be interpreted as a spring scene because it lacks any sense of the intense heat or bright glare of the sun that characterizes summer in New York. However, in *Across the Avenue in Sunlight, June 1918* Hassam clearly conveyed the vibrancy of the strong summer sun as it lit up the stone building by using highly saturated deep blues and violets for shadows and intensifying the hues of the warm colors. As a result, the glint of yellow on the limestone causes the entire facade to flicker, dazzling the eye as if it were blinded by the sun.

The dearth of summer flag images is best explained by the fact that Hassam normally spent that season in the country, away from the urban heat. During the years 1916 to 1918 Gloucester, Massachusetts, proved especially fruitful for his summer painting endeavors.[4] He seldom utilized the flag in country images, an exception being the lithograph *The Service Flag,* 1918 (fig. 38), in

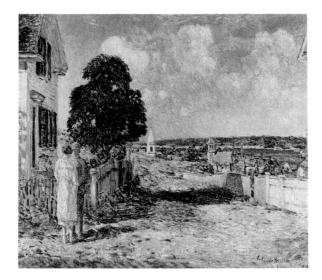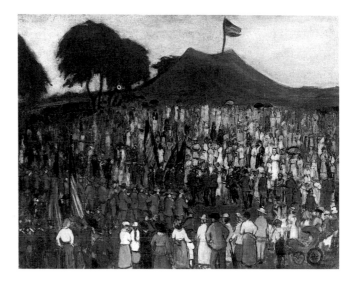

which a red and white flag with a field of stars hangs behind Old Glory;[5] the service flag was created in 1917 to indicate that a member of a family or business had entered the armed services. The war-related iconography in Hassam's imagery of bucolic Gloucester was usually confined to solitary figures of soldiers, as in *To the 101st (Massachusetts) Infantry*, 1918 (fig. 39).[6] Other artists were more inclined to acknowledge the impact of the war on rural communities. For example, in 1917 Theresa Bernstein painted a gathering of ordinary people at Fort Stage Park in Gloucester bidding farewell to the Eighteenth Regiment, which was leaving for France (fig. 40).

Hassam often did not return to the city from his summer residence until late September or early October, which may account for the limited number of autumn flag scenes. Five of the six paintings set in autumn (pls. 20–24) were inspired not by the season but by the elaborate decorations of the Fourth Liberty Loan Drive, which occurred in the autumn of 1918, and in these Hassam arranged the large flags so they obstruct most of the view of the sky. Even in the one other autumn scene, *The New York Bouquet: West Forty-second Street, 1917,* 1917 (pl. 12), the season is not at first obvious. The day is clear and the sky a cold blue, but the leafless trees in Bryant Park—the only true indicator of the season—are small and relegated to the area in the lower-left corner.

American impressionists were fascinated with the gold and orange hues that mark foliage in much of the United States during autumn, and for a few artists, such as Willard Metcalf and Theodore Steele, it was almost a specialty. Hasssam admired the special climatic conditions of autumn, even in the city, and is known to have thought that nothing compared with the view of the Manhattan skyline as seen in an October haze.[7] But Fifth Avenue in mid-Manhattan had no trees in the 1910s and consequently did not offer Hassam a significant pictorial motif for an autumn flag scene. When he did include trees in his flag

Fig. 39
Childe Hassam
To the 101st (Massachusetts) Infantry, 1918
Oil on canvas
30 x 25 in. (76.2 x 63.5 cm.)
Private collection

Fig. 40
Theresa Bernstein (United States, born 1886)
Eighteenth Regiment, Gloucester, 1917
Oil on canvas
28 x 36 in. (71.1 x 91.4 cm.)
Collection Adele A. Prayias, Greenwich, Connecticut

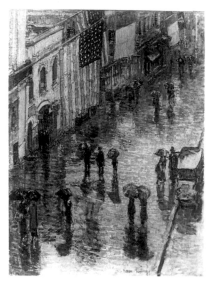

Fig. 41
Childe Hassam
SAINT PATRICK'S DAY, 1919
Oil on canvas
24⅛ x 20⅛ in. (61.3 x 51.1 cm.)
Museo Nacional, Palacio de Bellas Artes,
Havana, Cuba

images—*Just off the Avenue, Fifty-third Street, May 1916* and *Flags on the Friar's Club*, 1918 (pl. 16)—they were usually fully in leaf with the intense green and yellow hues of springtime.

Fewer parades and flag displays were organized during winter, and only five of the flag paintings were done in this season (pls. 5 and 13–14 and figs. 41–42). *Lincoln's Birthday, 1918 (the Flag of the City of New York above)*, 1918 (pl. 14), has the icy blue, almost purely white sky characteristic of winter in the northeastern United States. For the sky Hassam applied the paint fairly thickly in short, vertical strokes whose controlled evenness conveys a stillness contradictory to the flurry of flags. The foreground pavement and street have swirls of thin bluish paint over the off-white underpaint to suggest a wet surface, for on February 12 of that year New York had mild weather after several days of snow and rain.

Flags on Fifty-seventh Street, the Winter of 1918, 1918 (pl.13), is a snow scene, the archetypal winter image. A fascination with painting primarily white images developed in the late nineteenth century, encouraged by the art of James Abbott McNeill Whistler, and snow scenes were popular with American tonalists and impressionists. A number of the most notable American impressionists, such as J. Alden Weir and John Twachtman, resided in the Northeast, where snowy winters are common. Both artists created many snow scenes, usually of rural areas, Twachtman becoming the preeminent master of such images. Tonalists were also intrigued by the sense of mystery snow cast on an urban scene. Hassam preferred an urban context, and throughout his career he painted so many snow scenes of Boston and New York that he ranks as a major winter landscape painter. Given this fascination, it is surprising that *Flags on Fifty-seventh Street, the Winter of 1918* was his only flag image with snow. But by the 1910s Hassam was in his fifties, and freezing weather may have discouraged him from sketching out-of-doors. In fact this scene was painted from a window of his studio on West Fifty-seventh Street.[8]

In *Flags on Fifty-seventh Street, the Winter of 1918* Hassam completely omitted the sky by tilting up the street plane. He conveyed the weather conditions solely by color, tone, and brushwork. The overall impression is one of lightness, not brightness, for his palette is more restricted here than in any other flag painting. Blue—a popular color with impressionists—still dominates but is presented in the context of whites and grays. The underpaint is a soft gray, over which Hassam applied cool whites in long strokes to suggest snow. A cold, dark cobalt blue was used for the human and mechanical traffic. The only warm color notes—numerous touches of a rainbow range of hues that Hassam added to the buildings—are so varied and small they do not warm the scene. The more somber tonality of the painting distinguishes it from the other flag images and makes it one of the least celebratory.[9]

In several other flag paintings Hassam's choice of colors and handling of brushwork also convey the effects of inclement weather. Beginning with his views of Boston, the artist demonstrated a preoccupation with rain as a theme,

and he easily transformed this concern with weather and changing atmospheric conditions into impressionist terms. He was intrigued by the implications of such weather: the dampness and mood of inhospitable streets. *Rainy Day, Fifth Avenue, 1916,* 1916 (pl. 4), was so sketchily painted that large areas of the khaki-green underpaint are visible. This somber hue sets a drab tone to the entire scene despite Hassam's extensive use of shades of blue, purple, and orange-red. The extremely white sky further indicates a wet, cold day. The feeling of similarly overcast weather conditions is suggested by the same khaki-green underpaint in *Avenue of the Allies,* 1917 (pl. 10), despite the fact that no sky is visible. In *The Avenue in the Rain, 1917* the artist created inclement weather effects with an entirely different palette. Blues with a good deal of reds, purples, and their tints predominate. The extensive use of white and tints heightens the feeling of dampness. The effect of rain is further conveyed through the vigorous brushwork, which obscures all objects.

The two versions of *Saint Patrick's Day,* both 1919 (figs. 41–42), were rainy scenes. Although their color cannot be determined from available reproductions, Hassam seems to have painted the version now in Havana with a loose but fairly regular brushstroke.[10] In *Flags on the Waldorf, 1916,* 1916 (pl. 3), he greatly loosened his handling of brushwork in the foreground space of the street. Light blues and turquoise are swirled and zigzagged freely over a translucent underpaint to suggest the fluidity of water on a tar street. In the foreground of *Italian Day, May 1918* the paint is also more freely applied, and the ground is so wet that the Italian flag hanging from the building is reflected on the street as a blurry passage of green and red. In both instances the brushstrokes appear almost haphazardly applied, in direct contrast to the controlled, almost systematic arrangement of paint in the flag paintings with dry streets. *Afternoon on the Avenue, 1917* has a white sky that could indicate either low temperature or the sky clearing after a storm. The extremely impressionistic handling with nothing sharply in focus creates the feeling of a misty day.

Two of the most obviously rainy scenes, *Rainy Day, Fifth Avenue, 1916* and *The Avenue in the Rain, 1917,* were done at an early stage of Hassam's work on the flag images. Such depictions of rain called for the blurring of scenes and consequently obscured delineations of the flags. During the early years of the war, when most of the banners were the national flag of the United States, it was easy for the viewer to recognize them, even in the most blurred representation, just by the suggestion of a red, white, and blue palette and stars-and-stripes motif. As different banners, similar in color and design, began to appear in greater number in the street decorations, Hassam had to strive for greater clarity to ensure that the flags could be properly identified. As the series progressed, rain and mist interfered with Hassam's new concerns and had to be abandoned.

Hassam depicted all the flag scenes in daylight, none at twilight, even though he had long been fascinated by evening effects, as seen in his early views of Boston and his later assertion that the view of the Brooklyn Bridge in early

Fig. 42
Childe Hassam
SAINT PATRICK'S DAY, 1919
Oil on canvas
24½ x 20 in. (62.2 x 50.8 cm.)
Location unknown
Reproduced in Nathaniel Pousette-Dart, comp., *Childe Hassam* (1922), no plate number

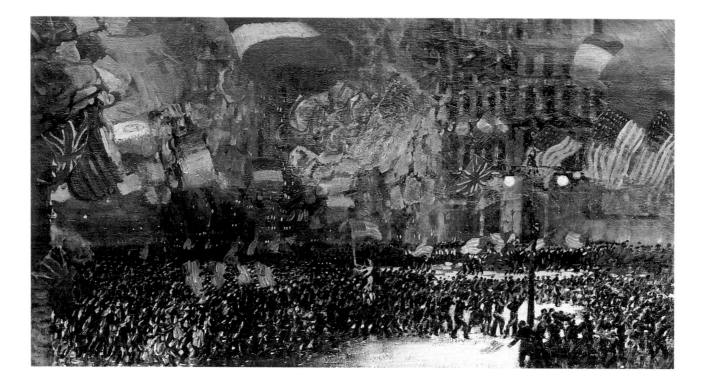

Fig. 43
George Luks (United States, 1867–1933)
ARMISTICE NIGHT, 1918
Oil on canvas
37 x 68¾ in. (94 x 174.6 cm.)
Whitney Museum of American Art,
New York
Anonymous gift

twilight mist was quite handsome.[11] Later wartime and victory celebrations were lit by electric lamps, and George Luks, for example, realized the spectacular potential for such images when he depicted the Allied flags flying over evening celebrations in *Armistice Night,* 1918 (fig. 43). Even the impressionist Theodore Earl Butler captured the excitement of Allied victory celebrations at night in his dazzling *Armistice, Times Square,* 1918 (fig. 44). However, Hassam thought the city's electric lights too crass a subject for painting; he compared the blaze of millions of electric light bulbs with the image of "a gigantic cut rate drug store."[12]

A critic noted in 1919 that Hassam's later work was usually set about midday rather than early morning or twilight because the artist preferred the day at its fullest with "its cup of sunshine brimming."[13] On a clear day he could faithfully depict a scene in all its clarity, as in *Allies Day, May 1917* and *Up the Avenue from Thirty-fourth Street, May 1917,* 1917 (pl. 9). The sun hitting the buildings during midday hours is especially strong and heightens the intensity of the colors and the richness of the shadow hues, as in *Across the Avenue in Sunlight, June 1918.* Hassam was less impressionistic in his brushwork in *Allied Flags, April 1917,* 1917 (pl. 7), but he again heightened the color to demonstrate the intensity of the sun as it illuminated the pinkish brownstone building of the Union League Club.

Hassam did sometimes set his flag scenes at different times. While *Early*

Morning on the Avenue in May 1917 seems as vivid as his midday scenes, *Victory Won,* 1919 (pl. 25), is pervaded by the delicate light of the morning hour of half past nine. In other scenes the shadows crisscross Fifth Avenue as the sun moves on its daily course through the sky. In *Avenue of the Allies: Brazil, Belgium, 1918,* 1918 (pl. 24), the late afternoon hour of four o'clock results in long shadows cast across almost the entire width of the avenue. In the other Avenue of the Allies paintings done during the Fourth Liberty Loan Drive (pls. 20–23), the alternating of light and dark passages along the avenue contributes to the flickering sense of light and color established by the flags as they gently move in the wind and heightens the overall sense of excitement.

Hassam might have had another reason for presenting the flags in strong, clear daylight. The artist was always aware of the mood of a city street: "The portrait of a city, you see, is in a way like the portrait of a person.... The spirit, that's what counts, and one should strive to portray the soul of a city with the same care as the soul of a sitter."[14] By portraying the flags in sunlight and against clear skies, Hassam was displaying the city's alert, upbeat spirit, a mood equivalent to Americans' belief that they could win the war. The flag images thereby became enthusiastic proclamations of America's power to be victorious.

The question naturally arises as to whether Hassam followed the impressionist practice of plein-air painting. If he worked on the flag images out-of-doors at any stage, there should be some proof, either in the existence of related preparatory sketches or some evidence in the paintings themselves. Pencil or painted sketches relating to his oils are rare in Hassam's oeuvre.[15] The only such work with a flag motif is *The Big Parade,* 1917 (fig. 45). Its configuration of national banners and service flags, as well as the composition, is analogous to Hassam's finished flag images dating from 1917. However, its handling is much bolder than that of any of the other flag paintings. The artist delineated the buildings on the left side by long stripes of brilliant red, white, and blue paint. The only flag painting that approaches such loose brushwork is *Rainy Day, Fifth Avenue, 1916.*

The large scale of the works in the flag series makes it unlikely that Hassam set up his easel in the open air on the crowded pavement. More plausible is the possibility that he began some of the images—those with a perspective at or near ground level—from a stationary cab or motor bus. In an 1892 interview he expressed his fondness for painting city streets from a cab, explaining that it enabled him to get close to the pedestrians.[16] He is known to have painted several of the flag images looking out of windows, and the ones with elevated perspectives necessitated his standing at an upper-level balcony or window.

Whether Hassam began the flag paintings out-of-doors or not, it is probable that he completed them in the studio. His finished paintings have the freshness of a sketch, and yet, as one critic noted, the artist not only completed the majority of them indoors but also "painted over his canvases many times"

Fig. 44
Theodore Earl Butler (United States, 1861–1936)
Armistice, Times Square, 1918
Oil on canvas
42 x 35¾ in. (106.7 x 90.8 cm.)
Private collection

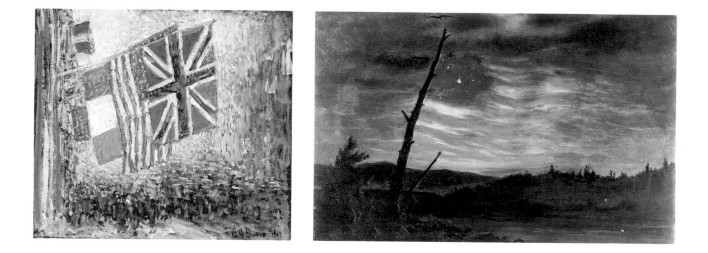

before they left his studio.[17] By the twentieth century even some of the French impressionists were no longer purists in their insistence on plein-air painting; Monet, for example, completed his Rouen Cathedral series in the studio. Many of Hassam's flag paintings, for all their freshness and sensitivity to transient conditions, lack the spontaneity expected from plein-air painting. This is especially true of the later images dating from 1918, which have a degree of finish, control, and structure derived from conscious planning rather than immediate response. Hassam's methodology reveals that there were factors other than impressionism at play in his art. These can best be understood by an analysis of his interpretation of the flag and city motifs. After all, it was not the brilliance of the sun or the charm of a rainy day that initially inspired Hassam to create the flag paintings but rather the flags themselves.

The image of the flag was not new to American art. It had appeared repeatedly throughout the late eighteenth and nineteenth centuries, mainly in narrative scenes of a historical or contemporary character. The United States flag appeared logically in views of national holiday celebrations, national elections, and parades (for example, John Louis Krimmel's *A Fourth of July Celebration in Center Square, Philadelphia,* 1819 [The Historical Society of Pennsylvania, Philadelphia]). The flag played its most significant role in war-related imagery, where national banners were displayed in battle scenes, such as Benjamin West's *The Death of General Wolfe,* 1770 (National Gallery of Canada, Ottawa), and John Trumbull's *The Capture of the Hessians at Trenton, New Jersey, 26 December 1776,* 1786–97 (Yale University Art Gallery, New Haven), as well as related events, such as Emanuel Leutze's *Washington Crossing the Delaware,* 1851 (Metropolitan Museum of Art, New York). Frederic Church created perhaps the most unusual flag image in *Our Banner in the Sky,* 1861 (fig. 46), where the sky above a barren

landscape was transformed into a battered United States flag to allude to the Civil War.[18] Because Hassam's flag paintings are scenes of home-front decorations in support of a war, they relate to both vital traditions: images of local patriotic festivities and of war.

The flag motif was seminal to Hassam's series of paintings. It served not only as the primary subject but also as a major formal element and supplied the symbolism for the entire series. Hassam's treatment of the flag was not consistent throughout the three years he worked with the imagery. The role of the flags and the artist's depiction of them changed with the emergence of a concept of what the flags meant and what the series should signify. Initially he was attracted to the flag displays because their color and design added to the exciting effect of the scene. The deep, rich reds and blues and the stars-and-stripes patterns offered the artist a lively array of formal elements with which to work. The flags contributed to the total impression of the scene but were not singled out for separate attention.

As the war progressed, the flag became more than a merely decorative element. Through its repeated appearance, especially in groupings of the American national banner with those of Great Britain and France, the symbolism became obvious. The flags represented not only each Allied nation but also came to signify the cooperation among the various countries supporting the Allied cause. Consequently in later paintings Hassam increased the size, scale, and clarity of the banners. He began using the flag to construct a composition that would underscore the special meaning of the series, and he developed a postimpressionist style to serve this iconographic need. His reinterpretation of the flag motif eventually emphasized its symbolism rather than its decorative effect.

Most of the earlier paintings, which more often reflect the theoretical tenets of a true impressionist, have small flags that hang in large groupings from rows of skyscrapers. The flags are usually sketchily delineated, as though seen through bright light or rainy mist. In *The Fourth of July, 1916, The Avenue in the Rain, 1917,* and *Afternoon on the Avenue, 1917*—three quintessential impressionist images—Hassam included countless United States flags. The repetition of the stars-and-stripes motif throughout the scene prevents any individual banner from being clearly seen. In *The Avenue in the Rain, 1917* and *Afternoon on the Avenue, 1917* most of the flags are indicated by short strokes of red, white, and blue paint. Hassam's effort to render an accurate record of weather conditions (wind, rain, and mist) dominates each image, making even the large flag in *The Avenue in the Rain, 1917* impossible to discern clearly. The overall effect of a grand display is achieved by including a large number of flags rather than isolated banners.

The flag paintings Hassam created the first year, in 1916, are especially illuminating with respect to the subsequent changes in his interpretation of the flag motif. In the first dated painting of the series, *Just off the Avenue, Fifty-third Street, May 1916,* the flags are not only small but few in number and seem to

Fig. 47
Childe Hassam
UNION LEAGUE CLUB, 1893
Watercolor on paper
17¾ x 13¾ in. (45.1 x 34.9 cm.)
Collection Union League Club, New York

have been added as an afterthought. It is as if Hassam, after experiencing the thrill of the Preparedness Parade, returned to a painting he had already begun and added a few flags to bring the New York image up-to-date. By July of that year he had rethought his interpretation and started to create imagery in which the flag decorations are essential to the scene. Still basically small in scale, they proliferate and are presented in considerable quantity throughout the scene. In *The Fourth of July, 1916* two flags along the right edge of the composition are large but do not stand out on their own, appearing only within the context of a large grouping. Hassam permitted the banners to appear as relatively large and clearly discernible objects in *Flags on the Waldorf, 1916* but relegated them to the middle distance, so they would not be too prominent.

The only 1916 flag painting in which Hassam placed large flags in a prominent position is *Rainy Day, Fifth Avenue, 1916.* Several banners lead the viewer's eye diagonally into the scene, from the foreground to the middle distance. This compositional device, as well as his silhouetting one entire flag against the sky, became important in the later flag paintings. This work links Hassam's early impressionist concerns with light and weather to his later emphasis on the flags themselves and serves as a prototype for the 1918 Avenue of the Allies images (pls. 20–24).

In 1917 Hassam no longer used the flag only as a repetition of color accents and brushstrokes to enliven the scene. Individual flags became prominent, increased in size, and moved closer to the foreground. New York was experiencing more frequent celebrations, and with the entry of the United States into the war the city was decorated with a greater variety of flags. The nation's many new Allies and the profusion of war-related organizations, each with its own banner, brought a host of flags that few could identify. If Hassam had continued to depict the Allied flags as small, often indistinct blurs, similar to the United States banners in 1916, the different flags would have been indistinguishable, and the symbolism of the Allied front composed of many nations would have been weakened. Consequently he began rendering the flags so they could be easily identified, even while sometimes retaining an ambiguity concerning the New York locale. What became paramount was the flags, not the sites.

In *Allied Flags, April 1917* Hassam used the wall of the Union League Club as a foil for the flags. Years before, he had painted the clubhouse as seen from the corner in a view that was similar to contemporaneous photographs, which typically showed the building on a diagonal from the opposite street corner (fig. 47). Hassam adopted a completely different approach in the flag painting, presenting the building straight on from the opposite side of the street. This is the only work in the series in which he did not depict the national banners or the city on even a slight diagonal or in a dramatic vista. The American flag hangs from a pole centered directly above the row of other national banners. Its placement higher than the other Allied banners accords with flag etiquette. By employing a strictly frontal view, Hassam emphasized the central, higher place-

ment of the flag and perhaps did so to suggest the importance of America's participation in the Allied cause. His placement of the building close to the front picture plane eliminated any indication of sky. Nothing—not the glare of sunshine or hazy atmospheric conditions—is permitted to hinder an accurate reading of the imagery. Even *Across the Avenue in Sunlight, June 1918,* which shares a similar perspective with its almost straight-on view and lack of sky, has more of an impressionist handling and a consequent loss of clarity.

The type of banners displayed and their arrangement were often predetermined by the specific event depicted. Yet Hassam determined the placement of the flags in pivotal points of the compositions in order to emphasize their symbolic role. For example, the American flag behind the British banner in *The Union Jack, April Morning, 1918* signifies in literal terms United States support of Great Britain. Hassam repeatedly underscored political alliances by grouping the flags of the United States, Great Britain, France, and Italy and presenting them in the same scale (pls. 8, 10, and 18). In *Victory Won* a large Stars and Stripes is isolated high up against the sky and seems as important as the enormous victory pennants in the foreground, thus alluding to the role the United States played in helping to win the war.

In many of the paintings from 1917 and 1918 elaborate banner decorations are scattered throughout the scenes, but the focus is placed on individual flags. Hassam brought some flags to the foreground and presented them as the largest, most dominant objects in view. Often he placed the flag or group of flags in or near the center of the composition, further underscoring their importance (for example, pls. 4–5, 15, 17, and 23). The use of a low viewpoint in several of the scenes causes the flags to be outlined and further isolated, either partially or fully, by the light sky. Such is the case with *Red Cross Drive, May 1918,* where the exactitude of the central placement of the large Red Cross banners and the symmetry of the skyscrapers contribute to the monumentality of the image.

In other examples Hassam chose an opposite approach, still placing the most significant flags in the foreground but along the edges of the composition. In *Early Morning on the Avenue in May 1917* he used a traditional *repoussoir* device by having two large flags, placed at the left edge, direct the viewer's eye into the scene. In other paintings the composition is less traditional in terms of Western art, with the flags massed mostly on one side, as in *Allies Day, May 1917, Lincoln's Birthday, 1918,* and *Italian Day, May 1918.* Such asymmetrical compositions were indebted to Japanese prints, which had a strong impact on late nineteenth-century art, especially impressionism and postimpressionism.

The flag motif became a compositional device that Hassam used to construct his pictorial design. The picture surface, with its lines, shapes, and sense of movement, became an entity to be considered separately. Indeed the design of the pictorial surface began to take precedence over the accurate depiction of the scene. Surrounding buildings were neutralized or minimized through color and soft brushwork, space was compressed, and the patriotic displays were

Fig. 48
Raoul Dufy (France, 1877–1953)
LA RUE PAVOISÉE, 1906
Oil on canvas
32 x 25⅝ in. (81 x 65 cm.)
Musée National d'Art Moderne, Paris
Gift of Mme Dufy

arranged to emphasize the angularity and flatness of the individual flags and the overall flatness of the composition.

The device of moving the flag close to the foreground resulted in flattening the images. In *The Union Jack, April Morning, 1918, Red Cross Drive, May 1918, Avenue of the Allies, 1918 (Haiti, Guatemala; Greece, France beyond)*, 1918 (pl. 21), *Avenue of the Allies: Great Britain, 1918 (the Flags of the Colonies: Canada and Anzac; Brazil and Belgium beyond)*, 1918 (pl. 23), and *Avenue of the Allies: Brazil, Belgium, 1918*, the large two-dimensional flags flying almost parallel to the picture plane obstruct movement into the scene. The views lose depth and are read in more two-dimensional terms. Even in *Allies Day, May 1917* the moderate-size flags in the middle distance block the progression back into space and, along with the large foreground flags of Great Britain, the United States, and France, create a strong pattern of lines and polygons. Although the flags preside over the scene in *Allies Day, May 1917*, they vie with Saint Thomas's Episcopal Church, which glows under the blazing sunlight. This effect is also present in *Lincoln's Birthday, 1918* and *Italian Day, May 1918*, where Hassam's use of soft opalescent tints for the buildings enabled the brilliantly hued flag decorations to dominate.

In *Allies Day, May 1917* Hassam resorted to extreme compositional manipulation. By using an oblique viewpoint from on high, he looked down on the flags flying from staffs attached to the buildings on the right. The receding view is limited to the middle distance. The sky, which by its mere existence conveys the suggestion of unlimited space, actually consists of short, regular brushstrokes that almost function as a screen prohibiting further movement backward. There is a tension between spatial recession and the pictorial plane that is not fully resolved. This sense of patterning and tension between depth and flatness is similar to, but far less assertive than, the effects in Dufy's rue Pavoisée flag series. The fauve artist created a flat design out of the brilliantly colored French flags, which barely seem to relate to the city view (fig. 48). The American modernist Marsden Hartley, who resided in Germany during 1913–15, was stimulated by the pageantry of the Central Powers and went a step further than Dufy in creating flat, abstract compositions from the geometric shapes and brilliant colors of decorative war regalia (fig. 49). While Hassam never manipulated his composition and picture plane to the extreme of Hartley or even of Dufy, he did reveal a willingness to deviate from nature. In this respect he departed from the theoretical tenets of impressionism and aligned himself with postimpressionism.

By the time of Hassam's flag paintings impressionism was an established aesthetic in the United States, and he was recognized as its leading American exponent. Yet the aesthetic Hassam espoused in the 1910s was not quite the same one he had adopted early in his career. French impressionism had evolved over the decades, inspiring new approaches and moving away from a faithful representation of nature. During the 1880s, when Hassam was first exposed to French impressionism, it was already undergoing a transformation at the hands

of such disciples as Monet, Pierre-Auguste Renoir, and Pissarro. Other artists, now known as postimpressionists, such as Paul Cézanne, Paul Gauguin, and Georges Seurat, rejected impressionist naturalism in their search for an art permitting greater self-expression.

Postimpressionism came to America about the same time as impressionism, and at the turn of the century American manifestations of postimpressionism were usually grouped under the general rubric of impressionism, their differences largely overlooked. Only recently have scholars begun to recognize a distinct postimpressionist trend in American painting. Maurice Prendergast, Twachtman, and Hassam, among others, in varying degrees, revealed a concern for picture making by creating compositions that emphasized abstract design, patterning, silhouettes, asymmetry, flattening of space, and the painted surface.[19] Hassam's departures from impressionism were explained by his biographer, Adeline Adams, as the artist's preference for adopting whatever approach best suited his theme: "Fascinated though he was with problems of light in its myriad phases...[he] believed that to follow a school was to fall into a rut."[20] Her description of Hassam's methodology made it sound more like that of a postimpressionist: "He valued design, selection, suppression of the irrelevant. He knew that a real defect of the early Impressionists' quality was that they often thought of a painting as a thing too sacred to alter, once the hour was up. As a 'designer with a sense of classic grace,' he knew that this defect leads naturally to a neglect of composition."[21]

Hassam carefully composed the placement of the flags in paintings such as *Allies Day, May 1917* and *Avenue of the Allies: Great Britain, 1918,* and it is this manipulation of space and design that distinguishes his late flag paintings from his earlier, truly impressionist ones. Indeed these late paintings evince an aesthetic close in spirit to the flag-bedecked views of Venice created two decades earlier by Prendergast, heralded as America's first postimpressionist (fig. 50).

Henry McBride, one of the earliest and most perceptive American critics of modern European and American art, noted Hassam's deviation from French impressionism in his review of the November 1918 exhibition of the flag series at Durand-Ruel: "Mr. Hassam pleased best with his color and with his ability to simplify a complex scene....He is never strong in perspective and sometimes distorts it like a very cubist. He seldom gets solidity when he attempts it and seldom gets what artists call 'the effect.' "[22] McBride expected Hassam's flag paintings to be authentic impressionist works, and having approached an analysis of them in those terms, he found them at fault. McBride felt Hassam had failed in the primary goal of an impressionist, that is, in achieving "the effect." A view of New York, even an impressionist one, should have been composed according to rules of aerial perspective, and McBride considered Hassam's perspective weak and distorted like that of a cubist. In referring to cubism, McBride was alluding to Hassam's willingness to manipulate the scene. By selecting, synthesizing, and transforming nature, the artist was able to focus on what he considered to be the important objects and to suggest their meaning.

Fig. 49
Marsden Hartley (United States, 1877–1943)
PAINTING NO. 5, 1914–15
Oil on canvas
39½ x 31¾ in. (100.3 x 80.6 cm.)
Whitney Museum of American Art, New York
Gift of an anonymous donor

97

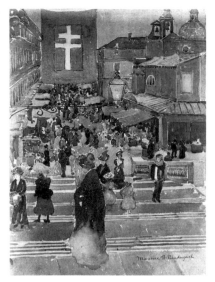

It was only then, in the late flag paintings, that Hassam focused on individual flags as emblems of national pride, liberty, and democracy and on specific groupings of banners as symbols of international alliances.

Like the flag iconography, the imagery of the New York metropolis contributed a specific meaning to the flag series, underscoring its modern and especially American connotation. New York at this period had come to stand for America and its technological prowess, which had surpassed that of Europe. The skyscraper was a product of that technology whose superiority would win the war, and the skyscraper city, draped with flags of freedom and liberty, symbolized the power to be victorious.

From his earliest years Hassam had painted the city where he was living, whether Boston, Paris, or New York. After returning from France in October 1889, he and his wife settled in New York and resided there for the rest of Hassam's life: "As time passed, he loved his adopted city more and more...for what he found of beauty in its daily life, its street scenes, vistas, parks, and countless horizons....He came to look upon New York as the most fascinating city on earth. It held all sorts of people. It had all kinds of weather, especially the good. He knew its nobility and its squalor. He called its skyline incomparable."[23]

Hassam's first views of New York did not deviate in conception from his images of Boston and Paris. They were picturesque, somewhat romantic views of pedestrians and street activities, usually seen from ground level (fig. 51).[24] He continued to create such scenes for years, and even two of the flag paintings demonstrate this old-fashioned conception of the city. In *Just off the Avenue, Fifty-third Street, May 1916* and *Flags on the Friar's Club* Hassam depicted a small, quiet side street devoted mainly to residential structures. Both scenes are narrative in focus, with the figures large enough so their activities can be identified. In both the view is from street level and oblique; neither the length of the street nor the height of the buildings is stressed. *New York Landscape,* 1918 (fig. 6), demonstrates a similar concept. Adams appreciated this less ceremonial treatment, writing that *Flags on the Friar's Club* and *New York Landscape* were "less resolute and martial than the Avenue canvases," yet "they have their own poetic appeal."[25]

Such a prosaic treatment is contrary to the approach Hassam used in most of the flag paintings, where he emphasized the high-rise buildings along Fifth Avenue and the traffic congestion. *Just off the Avenue, Fifty-third Street, May 1916* was the first of the series, and Hassam had not yet developed the concept of his flag images into the more ceremonial treatment that would dominate the paintings of 1918. Although he chose to use the more old-fashioned interpretation as late as May 1918, in *Flags on the Friar's Club,* it is significant that he never exhibited this canvas as part of the official flag series. It clearly did not fit the requirements of what he eventually conceived the series to be.

During the long period Hassam lived in New York it emerged as the modern city of the twentieth century. Like most American cities it experienced a

rapid increase in population during the late nineteenth century. In 1897 the boundaries of present-day New York were created when Manhattan, Brooklyn, Queens, the Bronx, and Staten Island were united to create a single municipality with a population of approximately 3.5 million. The rising population led to a need for more housing, and one solution was a further expansion of the populated areas of Manhattan north up to and beyond the environs of Central Park. The concomitant need for more workplaces ushered in the use of skyscrapers. During the 1890s tall buildings began to appear in New York and Chicago, transforming the urban skyline. In Manhattan the Flatiron Building was constructed in 1903 and the Woolworth Building a decade later. By the time of Hassam's flag paintings the city's first age of skyscrapers had already begun.[26]

Paris had undergone a similar expansion and modernization forty years earlier, its population having increased as a result of massive urban migration and the annexation of the nearby suburbs in 1860. Beginning in 1853 a comprehensive urban plan for renovation was undertaken during the Second Empire. Paris was to symbolize the glory of the empire—its past, present, and future. The city was redesigned according to the plan of Baron Georges-Eugène Haussmann; thousands of old buildings were demolished to enable the creation of dramatic boulevards. The French impressionists often focused on the new aspects, avoiding the old, narrow, twisted streets for what was modern and novel: boulevards, railroad stations, and parks. Though their urban landscape was always populated, the buildings and streets dominated. Their image of Paris came to be a majestic one presided over by grand buildings and sweeping avenues.[27] For American artists at the turn of the century and during the first decades of the twentieth century, New York held a symbolic importance equal to that of Paris for French artists.

Although New York was not the political capital of the country, it was the financial and cultural center and represented all that was distinctively modern. The skyscraper, a product of American technology and capitalism, became the icon of America's modernity. At first the modern city, with its emphasis on the skyscraper, was a highly debated issue. Henry James and William Merritt Chase deplored its lack of history and aesthetics, extolling the virtues of the traditional European city, while John Van Dyke and Robert Henri found the skyscraper beautiful and typical of all that America meant.[28] The philosopher George Santayana stated that the American will inhabited the skyscraper, while the American intellect the colonial mansion; one was all aggressive enterprise, the other gentility; one masculine, the other feminine.[29]

Hassam's first studio apartment was on Fifth Avenue and Seventeenth Street near Union Square, an area of lower Manhattan that appears countless times in the charming images from his first years in the city. Even more often he depicted the neighborhood surrounding Madison Square, a park farther uptown beside Fifth Avenue, which with its fashionable hotels, theaters, and shops was considered the heart of the society world during the late nineteenth

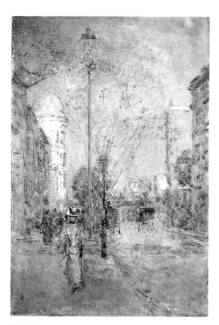

Fig. 51
Childe Hassam
SPRINGTIME—WEST TWENTY-SECOND STREET, NEW YORK, 1892
Oil on canvas
16⅜ x 10¾ in. (41.6 x 27.3 cm.)
Location unknown

century. One of Hassam's views of Madison Square is titled *Spring Morning in the Heart of the City,* 1890 (Metropolitan Museum of Art, New York). The wealthy and certain retail businesses moved farther up the avenue during the early years of the twentieth century. Hassam was part of this migration, settling into a new studio on West Fifty-seventh Street in 1908. Some of his best-known paintings and prints of New York depict the busy commercial area along Fifth Avenue in mid-Manhattan as far north as Central Park.

Unlike the Ash Can artists—realists who also painted American city life during the first decades of the twentieth century—Hassam was not interested in lower-class neighborhoods. He tended to portray the more refined elements of the city, and even when he depicted commercial districts, he chose places frequented by the middle or upper classes. Hassam's attitude reflected a less modern, elitist viewpoint characteristic of the nineteenth century, and this partly explains his fascination with Fifth Avenue, which was "born aristocratic."[30] The avenue was always devoted to polite society, both in the commercial and residential sense. By the time of World War I Fifth Avenue in mid-Manhattan, above Forty-second Street, was the city's fashionable shopping district, noted for its elegantly dressed crowds and delightful window displays. So socially conscious did the avenue become that it was considered improper for young women to walk below Forty-fifth Street. Commercial vehicles were banned from the avenue, and the motor bus charged double fare.

Although the grandest war celebrations took place at several sites—Wall Street, City Hall, Washington Square, Broadway, Madison Square, Fifth Avenue—Hassam chose to paint only those decorations along the avenue from Thirty-third to Fifty-ninth streets, the area where he lived and worked during most of the year. One of these street scenes was done looking out of his studio window (pl. 13), another from the window of one of his dealers, Macbeth Gallery (pl. 7), and others represent favorite buildings (pl. 22) and galleries he visited (pl. 19). At that time Fifth Avenue was not only the most gentrified area of Manhattan but also a section undergoing extensive and notable building construction. During the late 1890s and early twentieth century numerous commercial structures began to replace town houses and mansions, and these were often designed by leading American architects in the Beaux-Arts style of the period. By the 1910s a number of these buildings were skyscrapers.

In the flag paintings Hassam delineated many of the newer or more significant structures. For example, in his two images of the Thirty-fourth Street area (pls. 3 and 10)—the southern end of the elite shopping district—he juxtaposed the elegant Waldorf-Astoria Hotel, constructed between 1893 and 1898, with the more progressive, neoclassical-style facade of the Knickerbocker Trust and Safe Deposit Company, designed in 1902 by Stanford White (fig. 52). The opening of the Waldorf-Astoria had marked the beginning of a new era for Fifth Avenue north of Thirty-third Street. Among the other notable buildings Hassam included in partial views were some of the more venerable men's clubs—the Union League Club (pl. 7), the University Club (pl. 8), and

the Friar's Club (pl. 17)—as well as the high-rise Gotham Hotel (pl. 8) and the Aeolian Building (pl. 12). Although many of the taller buildings in Hassam's flag paintings cannot be specifically identified, it is interesting that the only one he singled out for special attention was the Bush Terminal Building (pl. 12), the tallest structure along Forty-second Street between Fifth and Seventh avenues, which had been completed about the time Hassam depicted it.

Saint Patrick's Cathedral, opened in 1879 and one of Hassam's favorite structures, appears in only one of the flag paintings (pl. 22). Saint Thomas's Episcopal Church on the corner of Fifth Avenue and Fifty-third Street was a newer addition to the avenue, completed in 1914 (pls. 1, 8, 11, and 22). The recurring imagery of these and other churches suggests that spiritual life was relevant to an urban dweller despite the busy, impersonal life-style of the modern city. Hassam's frequent placement of a church in conjunction with the Allied flags, often literally behind them, alludes to the moral right of the Allied cause (pls. 1, 8, 9, 11, and 22).

Although the first views of the skyscraper city were radical in subject matter, artists presented them in terms of traditional landscape conventions. The emphasis was usually on the picturesque, the romantic, or the dramatically sublime. Some Americans found city streets more appealing when cast in mystery rather than clearly defined. [31] The skyscraper often was shrouded by rain, snow, or evening twilight. Weir caught the mystery of the electrically lit city in *The Plaza: Nocturne,* 1911 (Hirshhorn Museum and Sculpture Garden, Smithsonian Institution, Washington, D.C.). However, it was tonalist painters and photographers who most frequently used a conservative aesthetic interpretation. They found that a poetic veil blurred details and softened the sharpness of the image, thereby making the modern angularity of the skyscraper more palatable. Birge Harrison's *Fifth Avenue at Twilight,* c. 1900–10 (Detroit Institute of Arts), is the quintessential tonalist urban image. None of the city views in Hassam's flag paintings were presented in such shadowy veils. The motif of the flag was too crucial to be obscured.

Hassam was one of the artists whose art by the turn of the century already reflected New York's altered appearance. He was aware of the physical changes and early on experimented with different interpretations, seeking the best way to present the city in modern terms. In *The Hovel and the Skyscraper,* 1904 (fig. 53), he utilized a high perspective for both formal and thematic purposes. The construction of a skyscraper, symbolizing the modern city, serves as the high vantage point from which the viewer can move into the scene to the hovel (an old riding stable) in Central Park. This sweeping vista also conveys the great breadth of the city. Hassam had even gone onto a roof, as seen in *Church of the Paulist Fathers,* 1892 (fig. 54), with its vista including the grand religious structure in the distance and a flag hanging from a pole on a roof. The flag series included a painting with a similar rooftop treatment: *The Flag, Central Park, Fifty-ninth Street, May 1918* (fig. 55). Hassam probably thought that such an interpretation was too prosaic, better suited to the Ash Can artists, because he

Fig. 53
Childe Hassam
THE HOVEL AND THE SKYSCRAPER, 1904
Oil on canvas
35 x 31 in. (88.9 x 78.7 cm.)
Mr. and Mrs. Meyer P. Potamkin

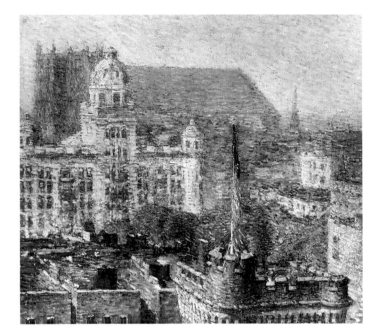
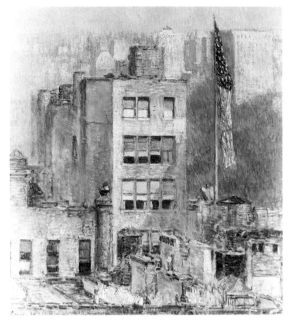

Fig. 54
Childe Hassam
CHURCH OF THE PAULIST FATHERS, 1892
Oil on canvas
22 x 24 in. (55.9 x 61 cm.)
Mr. and Mrs. Thomas M. Evans

Fig. 55
Childe Hassam
THE FLAG, CENTRAL PARK, FIFTY-NINTH STREET, MAY 1918, 1918
Oil on canvas
33 x 26 in. (83.8 x 66 cm.)
Location unknown

did not use it for any of the other flag paintings.

By the time of the war Hassam realized that the increasing scale of the city necessitated a new artistic interpretation. Consequently his focus turned from the urban dweller to the urban environment. Formerly a place of elegance and graceful spaces, New York was now a city where buildings loomed high over streets congested with constant activity. Hassam underscored the soaring verticality of the skyscrapers throughout the flag paintings. The most obvious means was the use of a vertical format. Most of the works in the flag series are similar in scale (about thirty-six by thirty inches or thirty-six by twenty-six inches), with a pronounced emphasis on the vertical. The street scenes in which Hassam chose to use a horizontal format appear at first to be anomalies (pls. 7, 11, and 19).

A single building towering high against the sky was, and still is, a dramatic view. Famous skyscrapers were depicted in this manner, such as the Flatiron Building in *Washington's Birthday,* 1916 (fig. 1). Hassam, however, rarely used the motif of a single building, and it appears only once in the flag paintings (pl. 12). He preferred a grouping of high-rise buildings haloed by the sky: "If taken individually a skyscraper is not so much a marvel of art as a wildly formed architectural freak....It is when taken in groups with their zigzag outlines towering against the sky and melting tenderly into the distance that the skyscrapers are truly beautiful."[32] Such groupings reappear throughout the flag series, as Hassam set the buildings dramatically against cloudy skies (pls. 2–3

and 18) or suggested distance by having the row of grand buildings melt softly into an opalescent sky (pls. 6 and 14). The artist often created a sparkling, almost jeweled wall of opalescent colors by rendering the white stone facades sparkling in brilliant sunlight (pls. 15, 19, and 22).

Hassam often viewed Fifth Avenue from street level or slightly above. Although such images are earthbound, the extreme height of the buildings is suggested by exaggeration and contrast of scale. A building is presented close to the picture plane in order to exaggerate the height of the ground floor, and minuscule figures of pedestrians are placed near it. This kind of treatment appears in his print views of Fifth Avenue (for example, fig. 56) and twice in his flag paintings: *Avenue of the Allies,* 1917, and *Early Morning on the Avenue in May 1917.* In these paintings the flags, although adding a festive note to the scenes and helping to date them, are not essential to the compositions.

For many of the other flag paintings Hassam stayed relatively close to the ground at curb level or perhaps was seated on the roof of a double-decker bus, but he stepped farther back from the scene to look up at the skyscrapers (pls. 2–3, 6, 17–18, and 20–24). Consequently the view is expanded and becomes a grand vista. The artist explained that standing too close to a skyscraper was like "sticking your nose in the canvas of an oil painting." One had to "stand off at a proper angle to get the right light on the subject."[33] The buildings in the foreground have their tops cut off by the edge of the frame, and this cropping of the image leaves to conjecture the exact height of the buildings. Along the entire or almost the entire edge of one side of a painting he sometimes placed a pilaster or corner of a building's facade to emphasize the dominant verticality of the scene (pls. 8, 9, and 22–24).

The row of high-rise buildings that began to line each side of Fifth Avenue formed steep walls and, when seen from a distance, resembled a canyon with an open view of the sky between the two sides of the street. Indeed the earliest appreciations of skyscrapers likened them to grand mountains and the streets between them to valleys and canyons. In 1893 Henry Fuller began his novel about Chicago, *The Cliff Dwellers:*

> These great cañons—conduits, in fact, for the leaping volume of an ever increasing prosperity—cross each other with a sort of systematic rectangularity, and...are in general called simply—streets. Each of these cañons is closed in by a long frontage of towering cliffs, and these soaring walls of brick and limestone and granite rise higher and higher with each succeeding year....
>
> High above this architectural upheaval rise yet other structures in crag-like isolation. El Capitan is duplicated time and again both in bulk and stature.[34]

Joseph Pennell and other artists felt the need to depict the new structures

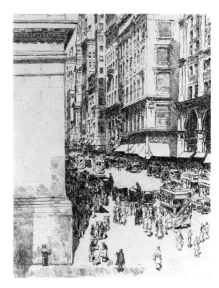

Fig. 56
Childe Hassam
FIFTH AVENUE NOON, 1916
Etching
9⅞ x 7½ in. (23.7 x 19.1 cm.)
The Metropolitan Museum of Art, New York
Gift of Mrs. Childe Hassam, 1940

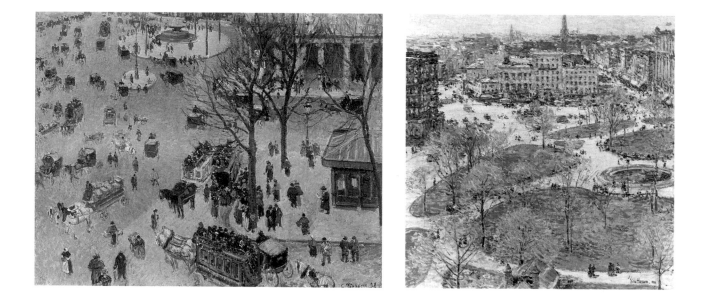

Fig. 57
Camille Pissarro (France, 1831–1903)
PLACE DU THÉÂTRE FRANÇAIS, PARIS, 1898
Oil on canvas
28½ x 36½ in. (72.4 x 92.7 cm.)
Los Angeles County Museum of Art
Mr. and Mrs. George Gard de Sylva
Collection

Fig. 58
Childe Hassam
UNION SQUARE IN SPRING, 1896
Oil on canvas
21½ x 21 in. (54.5 x 53.3 cm.)
Smith College Museum of Art,
Northampton, Massachusetts

in terms less foreign to the public. They compared them with nature because the skyscraper evoked in the viewer the same emotional responses to the sublime as did mountain views in the eighteenth and nineteenth centuries. Hassam's flag paintings in which the heights of the skyscrapers are greatly exaggerated through low perspective and dramatically contrasted lighting convey comparable feelings of awe in response to the grandeur and power of the buildings (pls. 2, 6, and 17–18).

In several flag paintings Hassam chose a more elevated vantage point—a second- or higher-story window or balcony—from which to record his scene (pls. 8, 9, and 13). A favorite interpretation of the impressionists, who first popularized such perspectives, involved looking straight down on a scene that is drastically tilted up, so that the horizon line is quite high or even omitted entirely; in this way the buildings, trees, and grass form a flat pattern of abstract shapes (fig. 57). Although Hassam employed that exact treatment in *Union Square in Spring*, 1896 (fig. 58), he chose to use it in only one flag painting, probably realizing that such a distorted viewpoint was better suited to small areas of the city, such as a park, rather than to a deep street vista. In *Flags on Fifty-seventh Street, the Winter of 1918* the street is tilted up and the space compressed, thereby emphasizing the congested, physically cramped buildings rather than the limitless sky and the power of tall structures. Such an effect contrasts with other 1918 flag paintings in which Hassam aimed at expansive presentations. Many of the news photographers who recorded the war parades and celebrations did so from upper-story windows or balconies of Fifth Avenue buildings (fig. 59). Their perspective encompassed ground activities as well as decorations on the upper stories of the buildings across and far up the avenue.

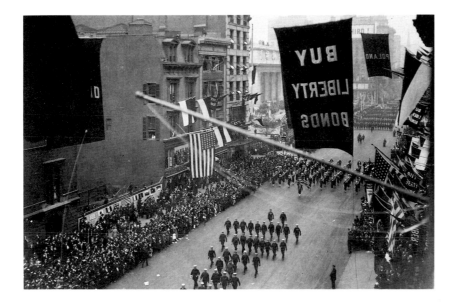

Hassam occasionally used this less extreme version of an elevated perspective, as in *Allies Day, May 1917* and *Up the Avenue from Thirty-fourth Street, May 1917* (pls. 8–9).

Hassam's scenes of the flag-bedecked city are alive with movement, and as early as 1892 the artist had explained: "I was always interested in the movements of humanity in the street.... There is nothing so interesting to me as people. I am never tired of observing them in every-day life, as they hurry through the streets on business or saunter down the promenade on pleasure."[35] Crowds and frenetic movement symbolized the dynamism of urban life. Van Dyke wrote in 1909:

Fig. 59
Press Illustration Service
Photograph of Fifth Avenue during Liberty Day Parade of the Fourth Liberty Loan Drive, October 12, 1918
The National Archives, Washington, D.C.

> There is a great movement going on about you, a surge of struggling humanity. If you are a stranger within the gates perhaps this means chaos to you, sheer mob madness.... The buildings are eruptive and the whole city abnormal....
>
> There is an explanation...for this. The city belongs to a republic, a great democracy. It is very apparent in New York that every one stands firmly on his rights as an individual....
>
> But the omnipresent interest of New York...is the passing throng, the great flux, the moving mass of people on streets....
>
> If there is one feature of the city predominant above all others it is its life, its vitality, its tremendous energy kept forever in action by commerce.[36]

In the flag paintings the pedestrians, though sometimes depicted singly

or in small groups, more often appear in great masses. Hassam created them with a minimum of brushstrokes, usually mere dabs of paint in one or two colors, which give the impression of a crowd of figures in flux. His pedestrians vary in degree of specificity, determined partially by their size and the weather conditions. When the figures are large in scale, they appear to be ordinary citizens; no soldiers are visible. Despite the state of war and the abundant decorations in the city, life goes on almost as usual.[37] In *Avenue of the Allies: Brazil, Belgium, 1918* Hassam moved away from an impressionist to a protoabstract handling of paint, drawing the foreground figures, which are large enough to be defined clearly, with calligraphic brushstrokes similar to John Marin's later abstract rendering of pedestrians.

A truly modern interpretation of the city's intensified pace did not appear until the 1910s. During that decade artists began expressing the city's dynamism by new means. Marin and others created less static urban images by fracturing the objects, so that the buildings and streets seem to move, and by distorting the views through multiple perspectives. Hassam's manipulation of his composition never reached the extreme distortion of the early abstractionists, nor did he ever relinquish his stationary viewpoint within a scene. He did move about and manipulate his perspective from scene to scene, so that as a group the flag paintings convey a multitude of views of the new, dynamic urban way of life. The tendency of artists less avant-garde than Marin was to demonstrate modernity and the urban life-style through the image of motorized and electrified vehicles, such as buses, elevated trains, and automobiles. Ash Can artists frequently depicted crowds of commuters frantically rushing about. John Sloan, in particular, was intrigued by the elevated train and automobile.[38]

Hassam likewise underscored the crowded and hectic life-style of the modernized city by his inclusion of buses and elevated trains. During the last four decades of the nineteenth century New York's inner-city transportation was transformed by bridges connecting the boroughs and an extensive elevated train system. The new mechanical means of transportation facilitated the rapid transit of thousands of employees into Manhattan and thus created the rush hour. After the introduction of the motor bus on Fifth Avenue in 1907, traffic became so heavy that a double-decker was needed to accommodate the crowds. The double-decker bus is a common motif in Hassam's flag paintings, its green color and rear diagonal stairwell leading up to the rooftop seats often the only means of identifying it in the congested streets (pls. 2, 3, 11, 14, 18, and 20–24).

In 1868 the first elevated train line began operating, and during the 1870s elevated train tracks proliferated in the commercial midtown area of Manhattan (by 1904 the first subway had also opened). The elevated train line was a significant motif in three of Hassam's flag scenes. In *Flags on the Friar's Club* the iron-trellis work of the Sixth Avenue line cuts harshly across Forty-eighth Street, an otherwise charming, tree-lined street. The train tracks are a visible intrusion into this quiet neighborhood but one that already seems to have been accepted and consequently ignored by its inhabitants. In *The New*

York Bouquet: West Forty-second Street, 1917 and *Flags on Fifty-seventh Street, the Winter of 1918* the station of the Sixth Avenue elevated line is placed in the background. These stations were the antithesis of modernity, their Victorian design, gingerbread ornament, and green color intended to be inviting.[39]

In *The New York Bouquet: West Forty-second Street, 1917* the station with its quaint roof emerges above the street traffic but is eclipsed by the enormous Bush Terminal Building, which thrusts assertively high above it. In *Flags on Fifty-seventh Street, the Winter of 1918* the high vantage point and lack of horizon negate the three-story height of the station. Because of its white cover of snow the station and its tracks are almost lost in the maze of nearby rooftops; the station is definitely not obtrusive. The iconography of the elevated train in the flag paintings reveals that Hassam viewed the mechanized urban transport system as just one of several essential elements of the modern city.

Hassam was also fascinated by urban thoroughfares crowded with automobiles (fig. 56). He did not deviate from this emphasis in his flag paintings but continued to portray streets choked with traffic. Automobiles are never shown as isolated examples but swarm in large clusters, their numbers and compact nature suggested by the artist's shorthand: repeated horizontal dashes of a single light color over a dark, usually blue field (pls. 2–4, 6, and 18). While not the focus of attention in these flag scenes, automobiles are essential to a correct reading of them, for the automobile had already taken its place as part of the iconography of modern America. Henry Ford's production of the Model-T, beginning in 1908, lowered car prices and quickly democratized automobile ownership in the United States. The automobile in particular represented an extension of the personal freedom Americans valued.

Unlike the automobile, the airplane was not yet part of daily civilian life in America. Invented only a decade before, it came into prominence during the war years largely because of its military usefulness for reconnaissance and combat. Biplanes were first used in combat in the early autumn of 1914 when Germany dropped explosives over Paris. Airplanes were also employed in the home-front efforts to raise money. Hassam included an aircraft in only one of his flag paintings, *Italian Day, May 1918,* which depicts a biplane high in the sky, literally at the top of the canvas, between rows of skyscrapers. This portrayal, emphasizing height, parallels how contemporaneous photographers viewed the airplane over the city (fig. 60). The French painter Robert Delaunay had already realized the potential of the plane as a symbol of modernity and speed in paintings done several years earlier, which Hassam might have known. The plane took on an additional significance for Hassam as an emblem of the Allied military's power to be victorious.

No more fitting environment could have been found for the flag displays than New York, for the modern metropolis epitomized all that was powerful, technologically advanced, and vital. Hassam must have realized this for he repeatedly used the setting and emphasized the new aspects of the city in order to enhance the symbolism of the flags.

Fig. 60
International Film Service
Photograph of Captain Emilio Resnati
flying over the Woolworth Building in
Lower Manhattan during Second Liberty
Loan Drive, October 1917
The National Archives, Washington, D.C.

Chapter 3

THE FLAG SERIES
AND ITS FATE

Fig. 61
Childe Hassam
*THE FLAG OUTSIDE HER WINDOW, APRIL
1918*, 1918 (also known as *BOYS
MARCHING BY*)
Oil on canvas
32 x 28¼ in. (81.3 x 71.8 cm.)
Location unknown

On November 15, 1918, only four days after World War I ended, Childe Hassam's flag paintings were first shown as a series at the prestigious New York gallery of Durand-Ruel. Originally intended as part of the ongoing home-front events, this presentation became part of the armistice celebrations. The exhibition title, "A Series of Paintings of the Avenue of the Allies by Childe Hassam," was based on the popular name recently accorded to Fifth Avenue during the celebrations of the Fourth Liberty Loan Drive. This title was the first public reference to Hassam's flag paintings as a series and may be the reason why in subsequent years, when some paintings lost their original titles, they became known under the general rubric "Avenue of the Allies."[1] It is not known when the concept of exhibiting the flag paintings as a series first took form or who originated the idea. It is unlikely that Hassam painted the first canvas with the concept in mind. Although he created flag paintings in increasing numbers immediately after the United States entered the war in April 1917, it may have been as late as May 1918 when the artist initially considered exhibiting them as a formal grouping.[2]

The series as shown at Durand-Ruel consisted of twenty-four paintings, including twenty city views with flags, three interiors, and a self-portrait.[3] The decision as to which paintings to include seems to have been made by the artist with the advice of dealer Robert Macbeth. All three interiors, now lost (figs. 61–63), were related to the window images Hassam created during the 1910s. In each interior a woman looks longingly out a window through which a flag can be glimpsed. Two of the women touch their breasts in gestures that clearly express their heartfelt concern for the fate of American men fighting overseas. A contemporary critic noted that the figure subjects "disclose Mr. Hassam's aim to preserve the human, emotional aspect of his gorgeous pageant."[4] The figures represented the wives, girlfriends, and families who kept "the home fires burning" as they waited for their men to return. Hassam realized that such paintings were criticized for lacking patriotic sentiment and war spirit, and although they are not flag paintings per se, he considered them as integral to his painted statement about America's response to the war: "I will want to include the picture of mine that you [Macbeth] are now exhibiting entitled, March 1917 [fig. 62]. . . . The painting commemorates the entry of the United States into the world war on April 6th, 1917. We arabians [*sic*] all know how we felt through that month of March 1917. It is not striking I admit, not arresting like an atrocity picture."[5]

It was at Hassam's suggestion that his self-portrait of 1914 (fig. 64) was added to the Durand-Ruel exhibition; however, it did not appear in any of the subsequent exhibitions of the flag series. Whereas the interior scenes symbolized the American people in general, the self-portrait expressed Hassam's own patriotic sentiment:

I fancy that you [Macbeth] would not object to including a self-port [*sic*] painted in June 1914. It portrays me in a sport shirt. . . . My face is red my

shirt is white and my hair is blue! My bandanna tie (a tie 'shows temperament' as the young lady art critic said) displays all the colors of the allied flags. I have always stood for these colors. As you know I am descended from that pure Arabian stock that landed in Dorchester in 1631. . . . So you see I have good reasons for being red white and blue.[6]

Even before the flag series Hassam had often been inclined to do paintings that were thematically related, although he seems not to have thought in terms of formal series. A series, in its broadest definition, is an ensemble of images related thematically or formally, which as a group expresses a concept that is difficult to convey wholly by an individual work in the group. Serial art had a solid tradition in the history of Western art. Landscape painting in particular, being about nature and therefore related to cyclical themes, was especially conducive to the concept of a series. Early painted series appeared as illuminated illustrations of the Labors of the Month, the Seasons, and the Times of the Day in medieval manuscripts.[7] During the nineteenth century landscape series became popular in Europe and also took hold in America, where the use of serial art was crucial to the concept of landscape painting espoused by Thomas Cole.

Through such series as "The Course of Empire" (New-York Historical Society) Cole expressed grand ideas about the progress of civilization and mankind. His series were symbolic in content, based on programmatic relationships between each painting, and derived their meaning through a continued narrative element.[8] Hassam's flag series was not preconceived and consequently does not symbolize such a methodically predetermined concept as Cole's series. Hassam may not have been familiar with Cole's art, which was not popular at the time, but late nineteenth-century American artists sometimes painted groups of similar landscapes. Not conceived as formal series, such paintings were used by artists to explore natural phenomena and formal issues through a sequence of images related by preestablished subject matter. Martin Johnson Heade, George Inness, James Abbott McNeill Whistler, William Merritt Chase, John Twachtman, Maurice Prendergast, and Hassam all painted thematically related landscapes and city views.

It is Claude Monet's serial art that provides the closest prototype for Hassam's flag series. The French impressionist's best-known series—the haystacks, Rouen Cathedral, and water lilies—date from the 1890s and later. As he completed each series, he exhibited them as a group, usually at the Paris gallery of Durand-Ruel, and thereafter exhibited individual examples abroad. Although Hassam did not have an opportunity to visit the exhibitions of any of Monet's series when they were shown as a group, he may have seen individual examples.[9]

Monet's intention in his series was to make a prolonged investigation of light, color, shape, and emotional effect within the confines of a limited subject matter. With each new series he refined his intention and approach. His first, the haystacks of 1889–91, was a step in moving away from a random recording of nature to the somewhat systematic fabrication of a series. Because of their

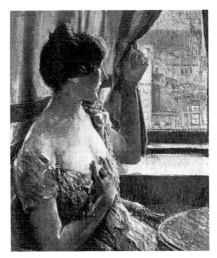

Fig. 62
Childe Hassam
MARCH, 1917 (also known as *THE FIFTY-SEVENTH STREET WINDOW*)
Oil on canvas
30 x 25 in. (76.2 x 63.5 cm.)
Location unknown
Reproduced as frontispiece in Cincinnati Museum, *TWENTY-SIXTH ANNUAL EXHIBITION OF AMERICAN ART*, exh. cat. (1919)

Fig. 63

Installation view, Durand-Ruel exhibition of Childe Hassam's flag series, 1918
One of the unlocated interiors, *THE HIGH BALCONY,* 1917, is the third painting from the left

early date the haystack paintings form a less coherent group than the later series. By the time of his Rouen Cathedral series of 1892–95 Monet was able to achieve a greater consistency of viewpoint, format, and color. Hassam did not systematically study any one motif or restrict himself to one street in New York, let alone the same vantage point. His flag paintings are closer to Monet's earlier, less structured series of haystacks than to the later Rouen Cathedral series.

With the poplars series of 1891–92 Monet began to reveal a concern for the figure-ground relationship that resulted in his simplifying the composition and emphasizing the rhythms and interrelations of line and form. Hassam likewise became increasingly concerned with surface design. In his late flag paintings there is often an ambiguous relationship between surface and spatial depth as the large flags assert their two-dimensionality and contribute to the flattening of the image. These flag paintings reveal an increased degree of abstraction, as did Monet's late series. [10]

Of Monet's Rouen Cathedral canvases one can speak of blue paintings, pink paintings, and so on, each demonstrating the effects of light at a different moment of the day. He finished the canvases in his studio in order to intensify

the subtle gradations that indicate specific times,[11] but it is not known to what degree Hassam reworked his flag paintings. He was never as vigorous as Monet in his need to record minute differences of the effects of sunlight. The flag paintings consequently appear less alike than any of Monet's serial paintings, even the haystacks, and this lack of uniformity may preclude their constituting a series. However, it is exactly Hassam's variety of interpretations—motivated by the impressionist desire to capture nature in all its myriad phases—that causes his flag paintings to function as an impressionist series.

The flag paintings also function as a postimpressionist series, that is, as a consciously synthetic ensemble of images with a specific iconography. Both Monet and Hassam used serial art as an exploratory device. For Monet the subject, be it haystacks, poplars, or water lilies, was merely a means to focus on formal issues. As Monet selected a single object, repeatedly presenting it in the same or similar compositions, the narrative and iconographic meanings of his subject matter lost significance. With Hassam the opposite occurred: his reengagement of the subject enabled him to discover and convey its meaning. His initial attraction to the flag displays was the tantalizing visual impression they created, but eventually the flags took on a symbolic importance all their own. This change may have occurred as early as the spring of 1917 when, in response to the United States entry into the war and to related home-front events, Hassam began creating more than an occasional flag painting. The artist investigated different formal treatments of the flag, varying perspective, composition, clarity, and scale, as well as different groupings of the flags, in order to find the most appropriate image that would underscore their meaning.

Hassam further expanded the symbolism of the flags through the repetition of the flag image in the context of the modern view of New York. The allusions to patriotism that national banners inspire are obvious, and in 1922 a critic wrote that Hassam's flag paintings "were filled with the poetry of patriotism," that "only a Puritan could have painted flags as he did."[12] As a series the paintings extolled the spirit of a new America, an international power to be reckoned with. Technologically more advanced than other countries but still idealistic, the United States emerged as a leader of the Allies, ready to assist in the liberation of the oppressed and in the advancement of freedom and democracy. The symbolism of Hassam's flag paintings was realized during his lifetime and became one of the prime rationales for establishing the series as a war memorial.

After the Durand-Ruel exhibition, the paintings were shown as a series five more times during Hassam's lifetime. The Carnegie Institute in Pittsburgh, which also hosted an abbreviated version of the "Allied War Salon," held a special exhibition of the flag series during the early spring of 1919. The paintings returned to New York to be exhibited that year at the Milch Galleries, Church of the Ascension, and College of the City of New York. The final showing was not until February 1922 at the Corcoran Gallery of Art in Washington, D.C.[13]

Fig. 64
Childe Hassam
SELF-PORTRAIT, 1914
Oil on canvas
32¹³/₁₆ x 20 ¾ in. (83.3 x 52.7 cm.)
American Academy and Institute of Arts and Letters, New York

The series as presented at Durand-Ruel reflected not only how Hassam conceived of it at the end of the war but also what paintings were available. The most significant omissions were *Allied Flags, April 1917* and *Allies Day, May 1917*, both 1917 (pls. 7–8); the former was still at the Cleveland Museum of Art and was exhibited as part of the series only at the 1922 showing at the Corcoran Gallery of Art. It is not known why *Allies Day, May 1917* was not included—perhaps it was part of another display—but it was purchased in 1919 and never shown as part of the series.

The series as formally exhibited changed as paintings were sold or added. The first exhibition consisted of twenty-four paintings (including the self-portrait), but at the last showing at the Corcoran Gallery of Art there were only nineteen paintings, including two that had not been in the original Durand-Ruel exhibition. The series was never a fixed entity. Most historians state that it consisted of twenty-two paintings, an assertion based on the number of paintings included when attempts were made to raise a public subscription to purchase the series for New York as a war memorial. The number twenty-two had symbolic importance because it represented the number of Allies.

As early as May 1919, during the exhibition at Milch Galleries, it was rumored that there was interest in keeping the series together.[14] The effort to retain it as a war memorial first emerged publicly the following autumn with the exhibition at the Church of the Ascension, where twenty-two flag paintings were shown along with holy relics from the church of Verdun. Arranged as a memorial to Theodore Roosevelt, who had died January 6, 1919, the show also had a long-range aim. According to the exhibition catalogue, the objective was to raise $100,000 by popular subscription for the acquisition of the entire set as a permanent public war memorial. The paintings were called "intimate, authentic historical records of New York City's war activities," which would remind future generations of "the valor of our men at The Front and of our answer to their appeal, 'Keep the Home Fires Burning.'"[15] The committee organized to raise the subscription included artists Daniel Chester French, who was also a trustee at the Metropolitan Museum of Art, and Frederick Mac-Monnies, as well as William H. Carpenter, provost of Columbia University; Leigh Hunt, art director at the College of the City of New York; Mary Fanton Roberts, editor of *Touchstone* magazine; and the Reverend Percy Stickney Grant, rector of the church. Their participation demonstrates that the series was considered to have an educational and religious dimension that added to its artistic value.

Just before Christmas the flag paintings were exhibited at the College of the City of New York for the express purpose of raising the subscription money. The plan was to have students and alumni assist in the drive and then to house the paintings at the college, where they would form the nucleus of its art museum. Hassam preferred to see the series remain intact. As the college newspaper explained: "Already twelve of the paintings have been sold to different purchasers over the country for more than $100,000, the amount asked by the

artist.... The above sales will be cancelled only on the condition that New York City buy the collection."[16] The number twelve was an exaggeration, as not even a dozen paintings were in private or public collections by the time of Hassam's death.

After the war there was a great demand for memorials to honor the nation's dead. Numerous articles appeared in art journals concerning war memorials, and what constituted the most fitting war memorial became a much discussed issue. The general national interest was reflected in the May 1919 issue of the *American Magazine of Art*, which was devoted solely to this topic. In New York the mayor established a special committee to determine the most appropriate permanent memorial, and in November the committee held a public hearing. In February 1920 the committee sponsored an exhibition of the ideas suggested; most were traditional in concept (victory or peace arches, obelisks, columns), but some were grander (entire buildings, bridges, park plazas). There seems to have been no mention of Hassam's paintings in either the exhibition or in the summary records of the municipal art committee. Although one exhibitor suggested a museum for American art, no one offered painted memorials, despite a strong American tradition of commemorating war heroes in paint.[17]

This tradition dated back to portraits ordered by private citizens to honor the heroes of the 1745 battle of Louisbourg and to portraits of the heroes of the War of 1812 commissioned by the City of New York. Indeed a similar project, on a national level, was begun in 1919 to honor the leaders of the United States and its allies.[18] War memorials had traditionally been large sculptural projects, and the memorials of World War I would prove to be the last important examples of this. Clearly Hassam's paintings did not fit into either traditional category: painted portraits or sculptural monuments.[19]

Hassam was well aware of the difficulty of securing enough support as well as sufficient funds to assure the survival of the series as a memorial to the war effort. His dealer Albert Milch must have written to the artist about the problems in selling the flag paintings as a group, for Hassam replied to him somewhat bitterly in a letter dated August 19, 1919:

> I have heard it before!! Nobody ever heard of New York subscribing anything for the fine arts.... They [the flag paintings] will probably be sold in the West somewhere—and the enthusiastic New Yorkers will have to pay railroad fare to go and see them!
> I don't care a damn what you do about it.[20]

A few weeks later a calmer Hassam wrote to Milch about a prospective buyer who was considering purchasing the flag paintings for a museum.[21] Although this did not materialize, Hassam remained confident he could sell the paintings as a group: "Sell a flag picture! I will sell the set!"[22] However, the subscription for the series was never raised, and the paintings were dispersed.

Notes

In the following notes shortened citations are used for all sources given in their entirety in the bibliography. When a source is cited only in the notes, the complete citation is given at first mention, and a shortened citation is used for subsequent references to that source.

Chapter 1
THE HOME FRONT

1. Hassam was born Frederick Childe Hassam in Dorchester, Massachusetts, in 1859. On his father's side the artist's earliest New England ancestor was William Horsham, who emigrated from England in the seventeenth century. The family name underwent spelling changes over the decades, giving rise to numerous published discussions about Hassam's national origins. A frequent mistake was the belief that the name was Arabic, and as a result Hassam often teasingly referred to himself as an Arabian. The artist began as an illustrator but soon turned to painting. He worked in oils and watercolors throughout his career and became involved in printmaking in 1915. Hassam lived in Boston until 1886, demonstrating his fascination with the city in his art. By the mid-1880s he began vacationing on Appledore, one of the Isles of Shoals off the coast of New Hampshire, where he first evinced two of his favorite subjects: landscapes and garden imagery. Hassam briefly traveled through Europe in 1883 and returned to Paris in 1886 to study at the Académie Julian. Upon his return to the United States in late 1889, he settled permanently in New York. He helped establish the secessionist group Ten American Painters in 1897. Hassam continued to travel frequently, visiting Havana in 1895, Europe in 1897 and 1910, and the West Coast several times beginning in 1908. He summered in New England, becoming an active member of the Cos

Cob and Old Lyme colonies in Connecticut, and beginning in 1910 frequently visited eastern Long Island. After World War I he bought a summer house in East Hampton, Long Island, where he died in 1935.

2. Hassam, interview by Dewitt McClellan Lockman, February 2, 1927, transcript, p. 26, Lockman Papers (microfilm, roll 503, fr. 384).

3. Details about the Preparedness Parade were derived from newspaper accounts, particularly "145,000 Will March to Call of Preparedness To-Day," *New York Tribune*, May 13, 1916, p. 1, col. 1, p. 5, cols. 3–5; "'Be Ready' Message Sent by Tramp of 12-hour Line," *New York Tribune*, May 14, 1916, p. 1, col. 7; and "125,683 Serious, Earnest Americans Emphasize Demand for Preparedness in Parade That Marches for 12 Hours," *New York Times*, May 14, 1916, pp. 1–4.

4. Weir discussed his participation in the parade and the need to support the war effort in correspondence with his patron, Charles E. S. Wood, which is quoted at length in Dorothy Weir Young, *The Life and Letters of J. Alden Weir*, ed. Lawrence W. Chisolm (New Haven: Yale University Press, 1960), pp. 253ff.

5. Brown, *American Painting from the Armory Show to the Depression*, pp. 72–73.

6. "Letters to the Editor," *New York Times*, July 24, 1918, p. 10, col. 6; and unidentified newspaper clipping from *The Transcript*, Hassam Papers (microfilm, roll NAA-1, fr. 625).

7. Kathleen M. Burnside, Chronology, in Guild Hall Museum, *Childe Hassam, 1859–1935*, p. 23. Hassam worked at this address from 1908 until his death.

8. William Coffin, Introduction, in American Art Galleries, *Illustrated Catalogue of American Paintings and Sculpture Contributed by Prominent Artists for the Relief Fund of the American Artists' Relief Committee of One Hundred* (New York, 1917), unpaginated.

9. M. Knoedler and Co., *Exhibition of Paintings and Sculpture by American Artists* (New York, 1915), unpaginated, cat. no. 35.

10. William Coffin to Hassam, December 16, 1916, American Artists' Committee of One Hundred Papers, Archives of American Art (microfilm, roll 506, fr. 211); and American Art Galleries, *Illustrated Catalogue*, cat. no. 116.

11. "Art War Society in First Report Reveals Varied Activities," *New York Herald,* November 17, 1918, sec. 2, p. 4, cols. 6–7.

12. Reproductions of *Allies Day, May 1917* were first sold under the auspices of the Militia of Mercy for fifty cents a copy and later for five dollars, with autographed versions selling for twenty dollars. In 1919 the Art War Relief sold autographed copies of Noyes's book for twenty-five dollars and the reproduction of Hassam's painting for thirty dollars. See unidentified newspaper clipping and typed note, Hassam Papers (roll NAA-1, fr. 566; and roll NAA-2, fr. 267).

13. D. J. R. Bruckner et al., *Art Against War: Four Hundred Years of Protest in Art* (New York: Abbeville, 1984), pp. 16, 48–52.

14. Yale University Art Gallery, *Art for the Masses (1911–1917): A Radical Magazine and Its Graphics,* exh. cat., text by Rebecca Zurier (New Haven, 1985), pp. 41–43.

15. Gallatin, *Art and the Great War,* pp. 33–34; and manuscript of *Art and the Great War,* pp. 1–3, Gallatin Papers (microfilm, roll 508, frs. 304–5). Because copies of the book are rare and the manuscript on microfilm is accessible in the Archives of American Art, citations are given for the published and manuscript versions. The manuscript differs little from the published text.

16. Brown, *Valentine's Manual of Old New-York,* p. 251.

17. Gallatin, *Art and the Great War,* p. 35, MS p. 3 (roll 508, fr. 305).

18. Letterhead of stationery, Division of Pictorial Publicity, December 15, 1918, letter, Gallatin Papers (roll 507, fr. 794).

19. Gallatin, *Art and the Great War,* p. 34, MS p. 1 (roll 508, fr. 304).

20. Bruckner, *Art Against War,* p. 16.

21. Gallatin, *Art and the Great War,* p. 34, MS p. 3 (roll 508, fr. 305).

22. *American Art Annual* 15 (1918): 29.

23. Gallatin, *Art and the Great War,* p. 51, MS p. 17 (roll 508, fr. 320).

24. Gallatin, *Art and the Great War,* p. 51, MS p. 17.

25. Brown, *Valentine's Manual of Old New-York,* pp. 262–63.

26. Written by artists ranging from etchers, cartoonists, and architects to portrait painters and stained-glass makers, these letters are in the Gallatin Papers.

27. The author was not able to locate a copy of the actual leaflet. However, it was summarized in newspapers throughout the country (for example, "Art at Home and Abroad," *New York Times,* September 22, 1918, sec. 8, p. 2, cols. 5–8), and much of it was reprinted in *American Magazine of Art* 10 (December 1918): 65–66. Many of the letters to Gallatin were in response to the newspaper summaries.

28. MacDonald to Gallatin, September 20, 1918, Gallatin Papers (roll 507, fr. 609).

29. Halpert to Gallatin, August 27, 1918; Gallatin to Halpert, August 29, 1918; Grabach to Gallatin, August 9, 1918; and Gallatin to Grabach, n.d., Gallatin Papers (roll 507, frs. 315–16, 319–20).

30. "Painted Landscapes as Range Finders for Guns," *New York Times,* April 14, 1918, sec. 5, p. 1, cols. 1–5; "Landscape Targets," *American Magazine of Art* 10 (December 1918): 47–48; and Eliot Clark, *History of the National Academy of Design, 1825–1953* (New York: Columbia University Press, 1954), p. 168.

31. Thayer's theories about natural camouflage were based on studies of the concealment of animals in their natural habitats. First published in 1896, his theories were widely discussed during World War I and led to the 1918 reissue of his *Concealing Coloration in the Animal Kingdom* (1909).

32. *American Art Annual* 14 (1917): 15; *American Art Annual* 15 (1918): 30; "What Local Artists Are Doing," *New York Herald,* October 6, 1918, sec. 3, p. 6, col. 4; and Homer Saint-Gaudens, "Camouflage and Art," *American Magazine of Art* 10 (July 1919): 319–22.

33. Gallatin, *Art and the Great War,* p. 52, MS p. 17 (roll 508, fr. 320).

34. Hassam, interview by Lockman, pp. 26–27 (roll 503, fr. 385).

35. *The North River* (Kleemann 27, Griffith 1), *Camouflage* (Kleemann 6, Griffith 8), and *The French Cruiser* (Kleemann 13, Griffith 13). Kleemann numbers refer to Kleemann Galleries, *The Lithographic Work of Childe Hassam;* Griffith numbers refer to Griffith, *The Lithographs of Childe Hassam: A*

Catalog. The North River is the estuary of the Hudson River between Manhattan and New Jersey.

36. "Childe Hassam Arrested," p. 24, col. 4.

37. "New York to Greet Envoys," *New York Times*, April 26, 1917, p. 2, cols. 3–4.

38. The author has been able to locate only newspaper coverage of an April 29, 1918, visit of the Blue Devils to New York ("French 'Blue Devils' Here to Boom Loan," *New York Times*, April 30, 1918, p. 5, cols. 2–5). However, *Blue Devils Marching Down Fifth Avenue* has traditionally been dated 1917. This dating is based on a list of acquisitions made by Duncan Phillips through Kraushaar Galleries, New York, in which the painting is listed in an entry for July 10, 1917. This date could refer to when it was purchased or sold by Kraushaar. It was definitely painted by June 24, 1918, the date on the receipt of payment from Kraushaar for Phillips's purchase. This evidence from the museum's archives was furnished by Grayson L. Harris, assistant curator of research, Phillips Collection. Stanley Cuba, "George Luks: A Biography," in Sordoni Art Gallery, Wilkes College, *George Luks: An American Artist*, exh. cat. (Wilkes-Barre, Pa., 1987), p. 35, inaccurately gave July 10, 1917, as the date of the painting.

39. Hoopes, *Childe Hassam*, p. 82.

40. "Third Liberty Loan for Victory Opens," *Sun* (New York), April 6, 1918, p. 10, col. 2.

41. *Armistice Day* is the title by which Beal's painting is presently known. However, the type, quantity, and arrangement of banners suggest that the artist did not depict the celebration of the end of World War I but rather a Red Cross pageant, either its spring 1918 drive or its Christmas Roll Call Week, which was held a month after armistice.

42. Magonigle's wife, Edith, was a muralist (see note 75 below) and also active in war efforts; she served as chairman of the Painters Committee of the Art War Relief. Other members of the commission were Herbert Adams, Paul W. Bartlett, Edwin H. Blashfield, and Charles Dana Gibson. See Gallatin, *Art and the Great War*, p. 53, MS p. 19 (roll 508, fr. 322).

43. The days and their countries are listed in "Each Day of Campaign to Be Dedicated to One Allied Nation," *New York Tribune*, September 28, 1918, p. 4, cols. 6–7.

44. As reported in the "Glory of Fifth Avenue," *Avenue* (Fifth Avenue Association) 2 (October 1918): 5, the framed canvas measured eight by sixteen feet. Each artist was listed daily in New York's newspapers, and the entire list is in "Open Air Studio at Public Library Most Interesting to the Public," *New York Herald*, October 13, 1918, sec. 3, p. 7, cols. 2–3. It is not known how the artists were chosen, but it is possible that Charles B. Falls, chairman of the committee in charge of the Liberty Studio, selected them. In the *New York Herald* article an unidentified critic questioned the selection, complaining that George Luks's inclusion would have been appropriate (p. 7, col. 4).

45. Frederick James Gregg, "William Glackens' Work Foremost in That Done for Liberty Loan," *New York Herald*, October 20, 1918, sec. 3, p. 7, cols. 1–2; and "'Miss Liberty' by Charles Dana Gibson Aids Liberty Loan Drive at Public Library," *New York Herald*, October 20, 1918, sec. 1, part 2, p. 5, cols. 3–5.

46. Gregg, "William Glackens' Work," p. 7, col. 2.

47. "Open Air Studio at Public Library," p. 7, col. 4.

48. "Avenue Exhibits to Aid Liberty Loan," *Avenue* 2 (October 1918): 15; "The Avenue of the Allies," *American Magazine of Art* 10 (November 1918): 29; and Gallatin, *Art and the Great War*, p. 53, MS p. 19 (roll 508, fr. 322), where the idea is attributed to Tack.

49. "Fifth Avenue One Long Art Show. Gayest Thoroughfare in the World," *New York Herald*, October 6, 1918, sec. 3, p. 6, cols. 1–3; "The Avenue of the Allies," *Literary Digest* 59 (October 19, 1918): 24–25; and "Avenue of the Allies," *American Magazine of Art*, p. 29.

50. "What Local Artists Are Doing," *New York Herald*, October 6, 1918, sec. 3, p. 6, col. 4; and "Avenue of the Allies," *Literary Digest*, p. 25.

51. Hassam to Gallatin, September 2, 1918, Gallatin Papers (roll 507, fr. 333).

52. N. N., "Art: A Great National War Pageant," *Nation* 107 (October 26, 1918): 496.

53. "Avenue of the Allies," *Literary Digest*, pp. 24–25.

54. The altar was dedicated on the first day of the drive. In 1918 Hastings also designed a Liberty Loan Shaft, which was placed in City Hall Park. See Curtis Channing Blake, "The Architecture of

Carriere and Hastings" (Ph.D. diss., Columbia University, 1976), vol. 1, pp. 318–19, 400.

55. Mayor's Committee of Welcome to Home-coming Troops, *Review and Parade of the 77th Division, May 6, 1919* (New York, 1919), unpaginated booklet in Mayor's Committee of Welcome to Home-coming Troops, 1918–1919, folder, Office of the Mayor (John F. Hylan) Papers, Municipal Archives, New York.

56. "Glory of Fifth Avenue," pp. 4–5.

57. Ibid., p. 4.

58. Ibid.

59. One hundred cables were placed across the avenue to support the large flags; 160,000 feet of bunting were needed to make the flags and banners, and 40,000 feet of rope and 18,100 feet of wire were used to attach the flags in place. A total of thirty thousand dollars was needed to realize the complete display. See "Glory of Fifth Avenue," p. 2; and "The New Glory of Fifth Avenue," *Avenue* 2 (November 1918): 4.

60. "Glory of Fifth Avenue," p. 2.

61. Ibid., pp. 1–2.

62. "Fifth Avenue," *Public* 21 (October 1918): 1289.

63. The Fourth Liberty Loan decorations were later loaned to Montreal for its Victory Loan Drive, which was staged on Saint Catherine Street, Montreal's Fifth Avenue. There was also discussion about sending them abroad. See "'Avenue of the Allies' Transported to Montreal," *Avenue* 2 (November 1918): 12; and an untitled article, *Avenue* 2 (December 1918): 14.

64. Robert Grier Cooke, speech, October 14, 1918, Liberty Loan luncheon, quoted in "Wonderful Achievements for A Most Glorious Cause," *Avenue* 2 (November 1918): 2.

65. The title is meant in its generic sense and might not have been Butler's original one. At least two of Hassam's flag paintings, *The Avenue in the Rain, 1917,* 1917 (pl. 5), and *Avenue of the Allies: Brazil, Belgium, 1918,* 1918 (pl. 24), have at times also been mistitled *Flag Day.*

66. Butler could have reversed the placement of the Brazilian flag for any number of reasons: to focus on banners of the major Allies, to deemphasize the flag because it was not well known, or for purely aesthetic reasons.

67. American Art Galleries, *Allied War Salon,* cat. no. 221.

68. "'Mrs. Mitchel Joins Red Cross' Great 'Christmas Roll Call,'" *New York Herald,* December 9, 1918, sec. 2, p. 5, cols. 2–3.

69. Frederick James Gregg, "Arthur B. Davies Becomes Sign Painter for the Red Cross, as Do Other Artists," *New York Herald,* December 8, 1918, sec. 3, p. 9, cols. 1–3; and Louis Bouché, interview by W. E. Woolfenden, March 13, 1963, transcript, Oral History, Archives of American Art, pp. 7–9. Gregg wrote that the panels were ten by seven feet, but Bouché, referring to them as "posters in oil on muslin," stated that the paintings done at the Penguin Club were forty-five by ten feet. The references may be to two different types of work. An insider's account of the paintings created by Bouché, Davies, and Guy Pène du Bois was given in du Bois's *Artists Say the Silliest Things* (New York: American Artists Group, 1940), pp. 192–94, 196.

70. For information on the victory decorations and festivities, see Mayor's Committee of Welcome to Home-coming Troops, *Review and Parade of the 27th Division, March 25, 1919;* idem, *Review and Parade of the 77th Division, May 6, 1919,* booklet (New York, 1919); and "Mayor's Committee of Welcome to Home-coming Troops," typed manuscript. Copies of both booklets and the manuscript are in Mayor's Committee of Welcome to Home-Coming Troops, 1918–1919, folder, Office of the Mayor (John F. Hylan), Municipal Archives, New York.

71. "Mayor's Committee of Welcome to Home-coming Troops," typed MS, p. 202.

72. Ibid., pp. 143–46a; this manuscript includes a complete list of artists involved and titles of their sculptures.

73. Ibid., pp. 154–62.

74. An unnamed *New York Tribune* writer, quoted in "Pageantry for Returning Heroes," *Literary Digest* 61 (April 12, 1919): 27.

75. "A Notable Series of Mural Paintings Executed for the Victory Celebration, New York," *American Magazine of Art* 10 (October 1919): 475–78. The other artists were W. T. Benda, Charles S. Chapman, Arthur S. Covey, James Monroe Hewlett, Edith M. Magonigle, and Frederick J. Waugh.

76. Bernstein, interview with author, May 7, 1987, New York.

77. See American Art Galleries, *Allied War Salon,* cat. nos. 257 and 257a. Under the title *Flags of the Allies, Allied Flags, April 1917,* 1917 (pl. 7), was listed and illustrated as no. 257a but might not have been exhibited. The Macbeth Gallery stock cards for "paintings unsold" state that *Allied Flags, April 1917* was sent in 1922 to the Corcoran Gallery of Art exhibition of the flag series directly from Cleveland. The files of the Cleveland Museum of Art also record the painting's going directly to the Corcoran but give the year as 1919 (Macbeth Gallery Papers, microfilm, roll 2821, fr. 124; and Delbert Gutridge, registrar, Cleveland Museum of Art, to author, July 1, 1987).

For more details about the Mystic Art Association and Cleveland Museum of Art showings, see correspondence in Macbeth Gallery Papers (roll 2580, frs. 788–89, 791, 795–96, 805; roll 2585, frs. 161, 175–76, 180, 190; roll 2598, frs. 1415–16; and roll 2599, fr. 1).

78. See Pennsylvania Academy of the Fine Arts, *Catalogue of the 113th Annual Exhibition* (Philadelphia, 1918), cat. nos. 383–84, 387–88.

79. See Montross Gallery, *Special Exhibition* (New York, 1918). The Hassam paintings were cat. no. 5, *Paris, 14th July, 1889* (probably *Fourteenth July, Paris, Old Quarter*); no. 6, *Flags at the Waldorf,* 1917 (probably pl. 10); no. 7, *Fifth Avenue Flags* (identity unknown); no. 8, *Fifth Avenue, February 1917* (not known if this was a flag painting); and no. 9, *Three Flags* (identity unknown).

Chapter 2
THE FLAG AS SUBJECT AND SYMBOL

1. Haskell, in Pousette-Dart, *Childe Hassam,* p. viii; and "Painting America: Childe Hassam's Way," p. 272.

2. Galerie Georges Petit, *Monet-Rodin,* exh. cat. (Paris, 1889), cat. no. 38. For a discussion of Americans' fascination with Monet's art prior to 1890, see Frances Weitzenhoffer, "The Earliest American Collectors of Monet," in *Aspects of Monet,* ed. John Rewald and Frances Weitzenhoffer (New York: Abrams, 1984), pp. 74–91.

3. Monet's observation point for *Rue Montorgueil* has been identified as looking north at the intersection of the rues Mandar and Greneta. Hassam stated that he painted *July Fourteenth, Rue Daunou* from his apartment balcony. See Daniel Wildenstein, *Claude Monet: Biographie et catalogue raisonné* (Lausanne: La Bibliothèque des Arts, 1974), vol. 1, p. 316, no. 469; and Hassam to J. Alden Weir, July 21, 1910, Hassam Papers (roll NAA-2, fr. 66).

4. Discussions with Kathleen M. Burnside of Hirschl & Adler Galleries, New York, have confirmed that Hassam usually spent July, August, and most of September in Gloucester.

5. The lithograph is inscribed "July 21, 1918" (Kleemann 36, Griffith 24).

6. *To the 101st (Massachusetts) Infantry* is similar to the lithograph *The Court, Gloucester* (Kleemann 7, Griffith 30), which is inscribed "August 4, 1918" and "To The 101st Mass. Infantry." A United States flag and a smaller banner flying briskly in the wind were added to the print.

7. "New York the Beauty City," p. 16, col. 1.

8. Joseph Gottlieb, interview by Kathleen M. Burnside, May 17, 1987.

9. Both versions of *St. Patrick's Day,* 1919 (figs. 41 and 42), are probably even less celebratory. However, because the lost version is known only through a photograph and the other is located in Havana, the author cannot compare their color and overall impression with the other flag paintings.

10. Hassam's two versions of *Saint Patrick's Day* were almost the same size and depicted similar streets on an oblique angle and from a high perspective. The one in Havana (fig. 41) was also known as *The New Flag.* Hassam altered this version in the lower-left corner sometime between 1919 and 1924. The artist wrote to a Mrs. Coykindall on April 9, 1924, "I had improved the picture (to my mind) by some slight repainting." See Hassam entry in Catalogue no. 6 (a typed account book), Milch Galleries Papers.

11. "New York the Beauty City," p. 16, col. 1.

12. Ibid., col. 4.

13. "Childe Hassam's Work in Various Medium [*sic*]," p. 12, col. 1.

14. "New York the Beauty City," p. 16, col. 4.

15. Lack of sketches confirmed by Kathleen M. Burnside.

16. Ives, "Talks with Artists," p. 116.

17. S. H., "Studio Talk," *International Studio* 29 (September 1906): 269.

18. For an analysis of Church's painting, see Doreen Bolger Burke, "Frederic Edwin Church and 'The Banner of Dawn,'" *American Art Journal* 14 (Spring 1982): 39–46.

19. The most important recent discussions on American postimpressionism are William H. Gerdts, "The Square Format and Proto-Modernism in American Painting," *Arts* 50 (June 1976): 70–75; Wanda Corn and John Wilmerding, "The United States," in National Gallery of Art, *Post-Impressionism: Cross-Currents in European and American Painting, 1880–1906,* exh. cat. (Washington, D.C., 1980), pp. 219–40; and High Museum of Art, *The Advent of Modernism: Post-Impressionism and North American Art, 1900–1918,* exh. cat., essays by William C. Agee, Peter Morrin, and Judith Zilczer (Atlanta, 1986).

20. Adams, *Childe Hassam,* p. 73.

21. Ibid., p. 77.

22. McBride, "Childe Hassam and the Americanization of Fifth Avenue," p. 10, col. 6.

23. Adams, *Childe Hassam,* pp. 69–70.

24. Hassam and other American impressionists, such as Theodore Robinson, Guy Wiggins, and Ernest Lawson, painted both rural and urban scenes with similar equanimity. See Corn, "New New York," p. 61.

25. Adams, *Childe Hassam,* p. 102.

26. New York experienced a lull in building construction after the Woolworth Building, partly because of World War I. See Stanley Andersen, "American Ikon: Response to the Skyscraper, 1875–1934" (Ph.D. diss., University of Minnesota, 1960), p. 143.

27. For information on the French impressionists' view of the city, the author is indebted to Sylvie Gache-Patin, "The Urban Landscape," in Los Angeles County Museum of Art, *A Day in the Country: Impressionism and the French Landscape,* exh. cat. (Los Angeles, 1984), pp. 109–16.

28. Schleier, *The Skyscraper in American Art,* pp. 6, 14.

29. Quoted in Andersen, "American Ikon," p. 147.

30. Henry Collins Brown, *New York of To-Day* (New York: Old Colony Press, 1917), p. 81.

31. For a discussion of the city as a sublime experience, see Corn, "New New York," pp. 60–61.

32. "New York the Beauty City," p. 16, cols. 2–4.

33. Ibid., cols. 2–3.

34. Henry Blake Fuller, *The Cliff-Dwellers* (New York: Harper and Brothers, 1893), pp. 1–2.

35. Ives, "Talks with Artists," p. 117.

36. John Van Dyke, *The New New York* (New York: Macmillan, 1909), pp. 7, 13, 16.

37. In *Art and the Great War,* p. 45, MS p. 12b (roll 508, fr. 315), Gallatin criticized Hassam for not including a single soldier or sailor in his scenes.

38. Gerald Silk, "The Automobile in Art," in Museum of Contemporary Art, Los Angeles, *Automobile and Culture,* exh. cat. (New York: Abrams, 1984), p. 71.

39. Robert C. Reed, *The New York Elevated* (South Brunswick, N.J.: A. S. Barnes, 1978), pp. 97–99, 133–35.

Chapter 3
THE FLAG SERIES AND ITS FATE

1. The term has even been applied inaccurately to flag paintings that Hassam created before the Fourth Liberty Loan Drive (for example, pl. 10).

2. Hassam to Gallatin, May 5 or 8, 1918, Gallatin Papers (roll 507, fr. 331); in this letter Hassam discussed exhibiting his flag paintings "in a lot." In June passing mention of such a showing was made publicly in a review of local exhibitions ("Here and There in the Art Galleries," p. 15, col. 1).

3. The following twenty-four paintings were in the flag series as exhibited at Durand-Ruel from November 15 to December 7, 1918:

cat. no. 1. *Avenue of the Allies: France, 1918 (the Czecho-Slovak Flag in the Foreground, Greece beyond),* 1918

2. *Avenue of the Allies: Great Britain, 1918 (the Flags of the Colonies: Canada and Anzac; Brazil and Belgium beyond),* 1918

3. *Avenue of the Allies, 1918 (Haiti, Guatemala; Greece, France beyond),* 1918

4. *Avenue of the Allies, 1918 (Allied Flags in Front of Saint Patrick's Cathedral, Service Flag on Union Club, China, Great Britain, Belgium beyond),* 1918

5. *Avenue of the Allies: Brazil, Belgium, 1918,* 1918

6. *Italian Day, May 1918,* 1918

7. *Red Cross Drive, May 1918,* 1918

8. *Lincoln's Birthday, 1918 (the Flag of the City of New York above),* 1918

9. *Flags on Fifty-seventh Street, the Winter of 1918,* 1918

10. *The Flag, Fifth Avenue, across Central Park at Fifty-ninth Street, 1918,* 1918

11. *The Union Jack, April Morning, 1918,* 1918

12. *Across the Avenue in Sunlight, June 1918,* 1918

13. *The Flag outside Her Window, April 1918,* 1918

14. *March 1917,* 1917

15. *Up the Avenue from Thirty-fourth Street, May 1917,* 1917

16. *Afternoon on the Avenue, 1917,* 1917

17. *Early Morning on the Avenue in May 1917,* 1917

18. *The New York Bouquet: West Forty-second Street, 1917,* 1917

19. *The High Balcony,* 1917

20. *The Avenue in the Rain, 1917,* 1917

21. *Just off the Avenue, Fifty-third Street, May 1916,* 1916

22. *Flags on the Waldorf, 1916,* 1916

23. *The Fourth of July, 1916 (the Greatest Display of the American Flag Ever Seen in New York, Climax of the Preparedness Parade in May),* 1916

24. *Self-portrait,* 1914

The three interiors were cat. nos. 13, 14, and 19. See Durand-Ruel exhibition catalogue.

4. [Cortissoz, Royal?], "Random Impressions in Current Exhibitions," May 25, 1919, p. 10, col. 7.

5. Hassam to Macbeth, November [4?], 1918, Correspondence, Macbeth Gallery Papers (roll 2598, frs. 1398–99).

6. Ibid., fr. 1398.

7. For a discussion of the concept of series, see Grace Sieberling, *Monet's Series,* Outstanding Disserta-

tions in the Fine Arts (New York: Garland Publishing, 1981), pp. 19–20.

8. For an analysis of the issue of serial art in Cole's landscapes, see Ellwood C. Parry III, "Thomas Cole's 'The Course of Empire': A Study of Serial Imagery" (Ph.D. diss., Yale University, 1970).

9. Hassam had ample opportunity to see individual examples from Monet's series at exhibitions of his work held at the New York galleries of Durand-Ruel. For example, from the Rouen Cathedral series he could have seen *La Cathédrale dans le Brouillard,* 1893 (private collection), and *Cathédrale de Rouen, Effet de Soleil,* 1893 (Museum of Fine Arts, Boston), in a 1914 exhibition, and *Le Portail (Soleil),* 1892 (National Gallery of Art, Washington, D.C.), in 1916.

10. Sieberling, *Monet's Series,* p. 17.

11. Ibid., pp. 134–35.

12. Haskell, in Pousette-Dart, *Childe Hassam,* p. viii.

13. Of the twenty-four paintings exhibited at the Durand-Ruel exhibition, twenty-two were shown at the Carnegie Institute from February 15 to April 1, 1919, with different catalogue numbers. The two paintings not included were Durand-Ruel cat. nos. 17 and 24. See Department of Fine Arts, Carnegie Institute, exhibition catalogue.

The Milch Galleries exhibition held from May 20 to June 30, 1919, and the Church of the Ascension exhibition from October 27 to November 27, 1919, included the same group of twenty-two paintings, with the same exhibition numbers. Durand-Ruel cat. nos. 15, 17, and 24 were not shown, and one painting, *Victory Won,* 1919 (pl. 25), was an addition to the series. See Milch Galleries and Parish House, Church of the Ascension, exhibition catalogues.

Because no catalogue exists, it is not known which paintings were exhibited at the College of the City of New York at the exhibition held from before Christmas 1919 to January 28, 1920. Because this showing was part of the effort to keep the series together as a war memorial, the group of paintings was possibly the same as exhibited at the Milch Galleries and the Church of the Ascension. A partial exhibition listing, with exhibition numbers similar to but not entirely the same as those of the Milch Galleries showing, was included in the college newspaper ("College to Exhibit Paintings of Childe Hassam," p. 6).

The nineteen paintings exhibited at the Corcoran Gallery of Art from February 7 to 28, 1922, did not include seven shown at Durand-Ruel (cat. nos. 9, 10, 11, 14, 15, 17, and 24). *Victory Won* was shown, and *Allied Flags, April 1917,* 1917 (pl. 7), was included for the first and only time. The painting exhibited as *Avenue of the Allies: Front of Saint Thomas's,* n.d. (Corcoran cat. no. 3), is probably *Avenue of the Allies: Brazil, Belgium, 1918,* 1918 (pl. 24). See Corcoran Gallery of Art exhibition catalogue.

14. "Hassam at Milch Galleries," p. 3.

15. Parish House, Church of the Ascension, *Patriotic Street Scenes by Childe Hassam,* unpaginated.

16. "Hassam Exhibit Is Very Popular," p. 2.

17. All information about the city's official effort to determine a suitable war memorial was derived from miscellaneous papers found in the Mayor's Committee on Permanent War Memorials, 1918–1925, folder, Office of the Mayor (John F. Hylan) Papers, Municipal Archives, New York.

18. For mention of World War I and earlier war portrait commissions, see William H. Gerdts, "Natural Aristocrats in a Democracy: 1810–1870," and Michael Quick, "Achieving the Nation's Imperial Destiny: 1870–1920," in Los Angeles County Museum of Art, *American Portraiture in the Grand Manner: 1870–1920,* exh. cat. (Los Angeles, 1981), pp. 27–60, 61–76, respectively.

19. Violet Oakley ("Memorials in Painting," *American Magazine of Art* 10 [May 1917]: 273–74) thought memorial chapels of paintings would be ideal war monuments, but she seems to have been in a minority. Even Daniel Chester French, who was on the honorary committee to raise the subscription for Hassam's flag series and who considered the paintings fine works that would have increasing value, did not want to be actively involved in the effort because the works were paintings, not sculpture (French to W. J. R. Keates, September 25 and 27, 1919, Daniel Chester French Family Papers, Library of Congress, Washington, D.C.).

20. Hassam to Milch, August 19, [1919], Milch Galleries Papers.

21. Hassam to Milch, September 3, 1919, Milch Galleries Papers.

22. Hassam to Charles E. S. Wood, October 21, 1919, Wood Papers.

Select Bibliography

Articles about home-front activities were numerous, and in general the author consulted the following newspapers and journals for the years 1917 to 1919: *Avenue* (Fifth Avenue Association), *New York Herald, New York Times, New York Tribune,* and *Sun* (New York). The preceding notes contain complete citations to specific articles.

The following bibliography is a highly focused listing of sources. The first section cites books, articles, and archives that are useful in the study of Childe Hassam and the flag paintings. The second section deals specifically with the flag series and gives chronological listings for the catalogues of flag-series exhibitions and related reviews and articles.

1. CHILDE HASSAM AND THE FLAG PAINTINGS

Books

Adams, Adeline. *Childe Hassam.* New York: Academy of Arts and Letters, 1938.

Allentown Art Museum. *The American Flag in the Art of Our Country.* Exh. cat. Introduction by M. L. D'Otrange Mastai. Allentown, Pa., 1976.

American Art Galleries. *Allied War Salon.* Exh. cat. Introduction by Albert E. Gallatin. New York, 1918.

Boyle, Richard J. *American Impressionism.* Boston: New York Graphic Society, 1974.

Brown, Henry Collins, ed. *Valentine's Manual of Old New-York,* n.s. 3. New York, 1919.

Brown, Milton. *American Painting from the Armory Show to the Depression.* Princeton: Princeton University Press, 1955.

Catalogue of the Etchings and Dry-Points of Childe Hassam, N.A. Introduction by Royal Cortissoz. New York: Scribner's, 1925.

Corcoran Gallery of Art. *Childe Hassam: A Retrospective Exhibition.* Exh. cat. Introduction by Charles E. Buckley. Washington, D.C., 1965.

Gallatin, Albert E. *Art and the Great War.* New York: E. P. Dutton, 1919.

Gerdts, William H. *American Impressionism.* Exh. cat. Seattle: Henry Art Gallery, University of Washington, 1980.

———. *American Impressionism.* New York: Abbeville, 1984.

Griffith, Fuller. *The Lithographs of Childe Hassam: A Catalog.* United States National Museum, *Bulletin* 232. Washington, D.C.: Smithsonian Institution, 1962.

Guild Hall Museum. *Childe Hassam, 1859–1935.* Exh. cat. East Hampton, New York, 1981.

Hoopes, Donelson F. *Childe Hassam.* New York: Watson-Guptill, 1979.

Kleemann Galleries. *The Lithographic Work of Childe Hassam.* Foreword by C. Henry Kleemann. New York, 1934.

Noyes, Alfred. *The Avenue of the Allies and Victory.* Acknowledgment by Caroline H. Griffiths and Helen S. Hitchcock. New York: Book Committee of the Art War Relief, 1918.

Pousette-Dart, Nathaniel, comp. *Childe Hassam.* Distinguished American Artists. Introduction by Ernest Haskell. New York: Frederick A. Stokes, 1922.

Schleier, Merrill. *The Skyscraper in American Art, 1890–1931.* Studies in the Fine Arts: The Avantgarde, no. 53. Ann Arbor: UMI Research Press, 1986.

University of Arizona Museum of Art. *Childe Hassam, 1859–1935.* Exh. cat. Essay by William E. Steadman. Tucson, 1972.

Articles

"Childe Hassam Arrested." *New York Times,* April 17, 1918, p. 24, col. 4.

"Childe Hassam's Work in Various Medium [*sic*]." *New York Times Magazine,* November 14, 1919, p. 12, col. 1.

"Childe Hassam." *Index of Twentieth Century Artists* 3 (October 1935): 169–83; suppl. p. 63.

Corn, Wanda. "The New New York." *Art in America* 61 (July–August 1973): 58–65.

Ives, A. E. "Talks with Artists: Mr. Childe Hassam on Painting Street Scenes." *Art Amateur* 27 (October 1892): 116–17.

"New York the Beauty City." (An interview with Hassam.) *Sun* (New York), February 23, 1913, sec. 4, p. 16.

Archives

Huntington, West Virginia. Huntington Museum of Art. Archives. "Art Collection of Mr. and Mrs. Arthur Spencer Dayton," manuscript.

New York. American Academy and Institute of Arts and Letters. Childe Hassam Papers (microfilm, Archives of American Art).

New York. New-York Historical Society.

Albert E. Gallatin Papers (microfilm, Archives of American Art).

DeWitt McClellan Lockman Papers. Lockman interview with Childe Hassam, 1927 (microfilm, Archives of American Art).

San Marino, California. Henry E. Huntington Library and Art Gallery. Charles E. Wood Papers.

Washington, D.C. Corcoran Gallery of Art. Archives. Correspondence to Childe Hassam.

Washington, D.C. Smithsonian Institution. Archives of American Art.

Macbeth Gallery Papers (microfilm).

Milch Galleries Papers.

2. THE FLAG SERIES

Catalogues

Durand-Ruel Galleries. *Exhibition of a Series of Paintings of the Avenue of the Allies by Childe Hassam.* Foreword by William A. Coffin. New York, 1918.

Department of Fine Arts, Carnegie Institute. *Childe Hassam: An Exhibition of Paintings, Flags of All Nations and Paintings of the Avenue of the Allies.* Pittsburgh, 1919.

Milch Galleries. *Flag Pictures and Street Scenes by Childe Hassam.* New York, 1919.

Parish House, Church of the Ascension. *Patriotic Scenes by Childe Hassam and Verdun Church Relics (Loaned by the French High Commission).* New York, 1919.

Corcoran Gallery of Art. *Exhibition of the Series of Flag Pictures by Childe Hassam.* Washington, D.C., 1922.

Bernard Danenberg Galleries. *Childe Hassam: An Exhibition of His "Flag Series."* New York, 1968.

Reviews and Articles

"Here and There in the Art Galleries." *New York Times Magazine,* June 16, 1918, p. 15, cols. 1–2.

"Childe Hassam Expresses New York's Spirit in Avenue of Allies." *New York Herald,* November 17, 1918, sec. 3, p. 3, cols. 1–3.

"November Exhibitions in Great Variety." *New York Times,* November 17, 1918, sec. 4, p. 4, col. 7.

"'Avenue of the Allies' at Durand-Ruel's." *American Art News* 17 (November 23, 1918): 2.

Cortissoz, Royal. "Art." *New York Tribune,* November 24, 1918, sec. 1, p. 13, cols. 6–7.

"Flags and the Man Who Paints Them." *New York Tribune,* November 24, 1918, sec. 3, p. 3.

McBride, Henry. "Childe Hassam and the Americanization of Fifth Avenue." *Sun,* November 24, 1918, sec. 1, p. 10, col. 6.

"Art Exhibition Opens Today at Institute." *Pittsburgh Post,* February 15, 1919, p. 3, col. 4.

Stranathan, May. "Splendid Art Works on View in Gallery." *Pittsburgh Dispatch,* February 15, 1919, p. 3, cols. 3–4.

"Hassam at Milch Galleries." *American Art News* 17 (May 24, 1919): 3.

[Cortissoz, Royal?]. "Random Impressions in Current Exhibitions." *New York Tribune,* May 25, 1919, sec. 4, p. 10, cols. 5–7.

"Notes on Current Art: Flag Pictures by Childe Hassam." *New York Times,* June 1, 1919, sec. 3, p. 4, col. 3.

"Painting America: Childe Hassam's Way." *Touchstone* 5 (July 1919): 272–80.

[Cortissoz, Royal?]. "Random Impressions in Current Exhibitions." *New York Tribune,* November 2, 1919, sec. 4, p. 9, cols. 4–5.

"Hassam's Flag Pictures: Effort to Preserve Them as War Memorial." *Sun,* November 2, 1919, sec. 1, p. 14, cols. 3–4.

"Plan to Keep Childe Hassam's War Paintings as Memorial." *New York Herald,* November 9, 1919, sec. 3, p. 10, cols. 5–6.

"College to Exhibit Paintings of Childe Hassam." *The Campus* (College of the City of New York), December 3, 1919, pp. 1, 6.

"Art Show at College." *American Art News* 18 (January 3, 1920): 20.

"Hassam Exhibit Is Very Popular." *The Campus,* January 8, 1920, p. 2.

Brigham, Gertrude R. "Washington's Own Artist Returns from Sick Siege:...Local Art Mention." *Washington Herald,* February 12, 1922, Theater section, p. 7, cols. 4–5.

"Notes of Art and Artists." *Star* (Washington, D.C.), February 12, 1922, sec. 3, p. 3, col. 2.

Lowe, David G. "The Banner Years." *American Heritage* 20 (June 1969): 54–58.

Acknowledgments

All exhibitions require the assistance and cooperation of many people. Warm thanks go to my colleague Michael Quick, curator of American Art, Los Angeles County Museum of Art. The idea of "The Flag Paintings of Childe Hassam" grew out of conversations I had with him, and throughout the various stages of organizing the exhibition and writing the catalogue he shared his expertise with me, offering much useful advice, encouragement, and critical assistance.

Several people assisted in locating flag paintings. Stuart Feld and Kathleen M. Burnside of Hirschl & Adler Galleries, New York, are compiling the catalogue raisonné of Hassam's art, and their help was invaluable. Thanks also go to Jennifer Groel, Burnside's assistant. Heartfelt thanks also go to Peter H. Davidson and the staffs of Graham Galleries and Guggenheim Associates, both of New York.

My library and archival research was greatly aided by a number of people who gave generously of their time and knowledge. Nancy Johnson, librarian, American Academy and Institute of Arts and Letters, New York, assisted in delving into the Hassam Papers. Among the others I would like to thank are Kenneth R. Cobb, assistant director, Municipal Archives, New York; Anne Diederich, museum library assistant, Los Angeles County Museum of Art; Barbara Dunlap, chief, Archives, City College of the City University of New York; Sharon Frost, curator, Photography Collection, New York Public Library; Nina Rutenberg Gray, assistant curator, Print and Photograph Collection, New-York Historical Society; Delbert Gutridge, registrar, Cleveland Museum of Art; Grayson L. Harris, assistant curator for research, Phillips Collection, Washington, D.C.; Catherine Keen, Archives of American Art, Washington, D.C.; Nancy C. Little, librarian, M. Knoedler and Company, New York; Steven Miller, senior curator, Museum of the City of New York; Susan Nulty, librarian, Special Collections, Henry E. Huntington Library and Art Gallery, San Marino, California; Jane Reed, librarian, Union League Club, New York; Hans Rogger, professor of history, University of California, Los Angeles; Whitney Smith, Flag Research Center, Winchester, Massachusetts; Roberta Waddell, curator, Print Collection, New York Public Library; and the staffs of the Archives of American Art, San Marino; New-York Historical Society Library; Print and Photograph Division, Library of Congress, Washington, D.C.; and Still Pictures Division, National Archives, Washington, D.C.

The staff of the Los Angeles County Museum of Art helped in a variety of important capacities, and I owe them my gratitude. Above all I would like to thank Lisa Murphy, departmental secretary, Anita Feldman, assistant registrar, Press Officer Pamela Jenkinson and her staff, and Edward Weisberger, who skillfully edited the catalogue.

Ilene Susan Fort

Lenders to the Exhibition

Addison Gallery of American Art,
　　Phillips Academy, Andover, Massachusetts
Collection of the American Academy
　　and Institute of Arts and Letters, New York
Amon Carter Museum, Fort Worth, Texas
The Art Museum, Princeton University, New Jersey
The Eleanor and C. Thomas May Trust
　　for Christopher, Sterling, Meredith and Laura May
Mr. and Mrs. Thomas M. Evans
Mr. and Mrs. Hugh Halff, Jr.
Hirshhorn Museum and Sculpture Garden,
　　Smithsonian Institution, Washington, D.C.
Huntington Museum of Art, West Virginia
IBM Corporation, Armonk, New York
Kennedy Galleries, New York
Los Angeles County Museum of Art
Mead Art Museum, Amherst College, Massachusetts
The Metropolitan Museum of Art, New York
Musée National de la Coopération
　　Franco-Américaine, Blérancourt, France
National Gallery of Art, Washington, D.C.
The New-York Historical Society, New York
Mr. and Mrs. Richard J. Schwartz
Collection of Mr. and Mrs. Frank Sinatra
Telfair Academy of Arts and Sciences, Inc.,
　　Savannah, Georgia
The White House
Anonymous lender

Photo Credits

All photographs are reproduced courtesy of the works' owners. In addition the following credits are specified for the indicated figures and plates.

Courtesy American Academy and Institute of Arts
 and Letters, New York: fig. 61
E. Irving Blomstrann: fig. 58
Will Brown: fig. 39
Courtesy Christie's, New York: fig. 45
Geoffrey Clements: figs. 43, 49, and 64
© Cliché Musées Nationaux: fig. 36 and pl. 20
Jeff Conley: pl. 24
Courtesy Frick Art Reference Library, New York:
 fig. 47
Daniel L. Grantham, Jr., Graphic Communication,
 Savannah: pl. 10
Courtesy H. V. Allison Gallery, New York: fig. 20
Helga Photo Studio: figs. 6, 33, 44, 50, 54, and
 55 and pls. 6 and 9
Courtesy Hirschl & Adler Galleries, New York:
 figs. 6, 55, and 63 and pl. 2
Courtesy Janet Marqusee Fine Arts Ltd., New
 York: fig. 40
Paulus Leeser: fig. 8
Linda Lorenz: pl. 3
Courtesy The National Archives, Washington,
 D.C.: fig. 19
Courtesy Photographic Archives, National Gallery
 of Art, Washington, D.C., from a negative
 made by Taylor and Dull for Parke-Bernet
 Galleries, Inc.: fig. 51
Courtesy R. H. Love Galleries, Chicago: fig. 25
James L. Sheldon: pl. 11
Courtesy Sotheby's Inc., New York: fig. 32
Ken Strothman, Harvey Osterhoudt: fig. 16
John Tennant: pl. 15